HAUNTED
VIRGINIA BEACH

HAUNTED
VIRGINIA BEACH

Alpheus J. Chewning

HAUNTED
AMERICA

Published by The History Press
Charleston, SC 29403
www.historypress.net

Cover Image: The keeper of the Cape Henry Life Saving Station posed with his family for this dramatic photograph, dated 1911. *Courtesy of the Old Coast Guard Station.*

First published 2006

Manufactured in the United Kingdom

ISBN 1.59629.188.5

Library of Congress Cataloging-in-Publication Data

Chewning, Alpheus J., 1954-
 Haunted Virginia Beach / Alpheus J. Chewning.
 p. cm.
 ISBN 1-59629-188-5 (alk. paper)
 1. Haunted places--Virginia--Virginia Beach. 2.
Ghosts--Virginia--Virginia Beach. 3. Virginia Beach (Va.)--History. I.
Title.
 BF1472.U6C49 2006
 133.109755'51--dc22
 2006023851

Contents

Introduction

There's no doubt about it, there are a lot of books out there about ghosts and hauntings. That certainly became obvious to me when I sat down to write my own. My initial reaction was that it would be difficult, if not impossible, to find new stories to tell, but I was gravely mistaken. Although many people often don't discuss their stories openly for fear of being ridiculed, they are more than willing to share them with someone who agrees to listen without being judgmental, especially if that person is also a believer.

Ghosts aren't new. They are not a fad. They have been part of human culture since the beginning of recorded history. They appear in classic literature (Shakespeare's *Hamlet*, circa 1600; Dickens's *A Christmas Carol*, 1843) and in modern movies (*The Ghost and Mrs. Muir*, 1947; *Ghost Hunters*, 2004). They are part of our language when we use the phrases "a ghost of a chance" or "haunted by guilt." We even entertain our children with *Casper, the Friendly Ghost*, and at Halloween we encourage them to cover themselves with sheets and go trick-or-treating as little ghosts.

Why is it that some people look at us like we have three heads when we admit that we believe in ghosts? I suppose that could be the subject of another book, but not one I'm going to write. I'm not ashamed of the things I believe in. I believe in true love. I believe the designated hitter rule should go away. I believe barbeque is a noun, not an adjective or a verb. And I believe in ghosts.

Thank you for buying this book. I hope you will enjoy reading it as much as I enjoyed writing it. I hope it puts you in good spirits.

Blackbeard the Pirate

As certain as the sun behind the Downs
And quite as plain to see, the Devil walks.
—Sir John Betjeman

When many think of the notorious Blackbeard the pirate, the Outer Banks of North Carolina automatically come to mind. From 1716 to 1718 Blackbeard became the most feared pirate on the sea, capturing at least forty ships. By 1718 he had a fleet of four ships and nearly three hundred men under his command.

Some historians believe that Blackbeard was actually a very fair and amiable sort; at least to those he liked. He wasn't a psychopath who killed for the fun of it or who collected human ears as trophies. Of course, once he supposedly cut off a man's finger (or possibly his entire hand) after the man refused to surrender his ring; there was also the time he shot his own first mate in the leg to prove to his crew that he had no favorites.

Blackbeard certainly understood psychology and used this to his advantage. Being over six feet in height, the pirate captain towered

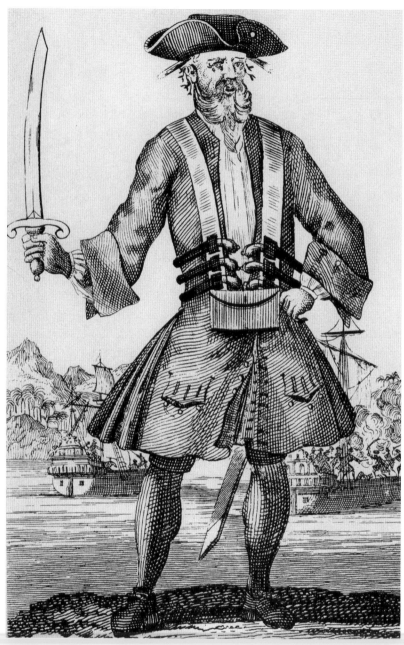

A woodcut of the pirate Blackbeard armed for battle with his cutlass and six pistols. *Courtesy of the Old Coast Guard Station.*

over most other men like a giant. To make himself appear even more fearsome, he grew a thick, full beard that covered his entire face and was known to decorate it with bits of colored ribbon. In battle, Blackbeard carried two swords and six pistols and put slow-burning fuses in his hair and beard so that his head would be shrouded in smoke. No doubt he looked like a demon to the superstitious men of his day. Because of his reputation, when most merchantmen saw Blackbeard's ships approaching, they surrendered without a fight.

The Outer Banks of North Carolina became the base of operations for the pirates. The location provided quick access to the shipping lanes, the many bays and inlets provided concealment, and the narrow channels and treacherous currents discouraged uninvited guests. Bath, North Carolina, was the seat of government in 1718 and the home of the state's governor, Charles Eden. Knowing the pirate's cruel reputation, Eden offered a full pardon in exchange for Blackbeard's promise to retire from piracy. The pirate went to Bath to accept the offer.

For a brief period Blackbeard, whose given name was Edward Teach (or Thach), enjoyed his retirement much like any other man would. He spent his great wealth freely and even bought a house in nearby Beaufort. The pirate and the governor soon became close friends. Governor Eden even officiated at the marriage of Blackbeard and his fourteenth wife, sixteen-year-old Mary Ormond. The wedding was attended by dozens of the pirate captain's old friends who began making frequent visits to the quiet little hamlet.

It didn't take long at all before Mr. Teach grew bored with the mundane life of an honest man. Hearing about the exploits of his friends persuaded Blackbeard to resume his chosen profession. In exchange for a portion of the ill-gotten gains and a promise that vessels sailing along the North Carolina coast would not be pirated, Governor Eden agreed to turn a blind eye on Blackbeard's activities. With the Carolina coast off limits, Blackbeard frequently sailed north to prey on the heavily laden merchant ships entering the Chesapeake Bay. When his ships could carry no more, he would return to his sanctuary.

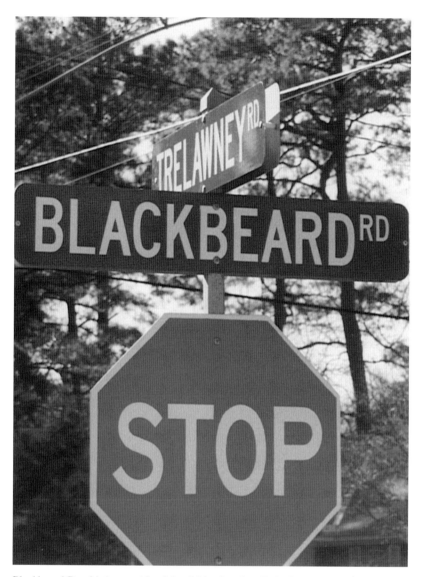

Blackbeard Road is in a residential neighborhood on Lake Joyce in Virginia Beach. There is a small island on the lake known unofficially as "Treasure Island" that was once thought to be where the famous pirate had buried his treasure. *Photo by author.*

On November 22, 1718, Blackbeard met his death, courtesy of Lieutenant Maynard of the Royal Navy. At the time, Maynard was actually working for the Governor of Virginia, Alexander Spotswood. Spotswood had heard rumors that Blackbeard had plans to fortify his position in North Carolina. Doing so would give the pirate complete dominance of the mid-Atlantic coast. Since Governor Eden was not going to take action to prevent this, Spotswood did.

The pirate's final fight was a bloody one. Blackbeard and Maynard fought hand-to-hand as the pirates and the Englishmen battled around them. The advantage went back and forth several times. Near the end, although he suffered five bullets and twenty sword wounds, it appeared that Blackbeard was about to defeat his adversary. However, a Scottish member of Maynard's crew stepped between the pirate and the lieutenant, wielding a heavy broadsword. The Scotsman beheaded the pirate with a single blow.

Lieutenant Maynard stayed in Bath for several weeks until his ships had been repaired. Then, commanding the *Avenger*, one of Blackbeard's old ships, Maynard returned to Virginia. Blackbeard's severed head was hung from the bow of the ship and delivered to Governor Spotswood upon Maynard's arrival.

So what is the link between Blackbeard and Virginia Beach? Why is there an area at the oceanfront called "pirate's hill"? Why is there a Blackbeard Road in a city that is not mentioned in any written history of the pirate captain's activities? Maybe the answer is in this story that was told to me by my high school English teacher, who grew up in Virginia Beach and often shared his childhood memories with the class.

There is a landmark that appears on local maps that date back as far as the late 1600s. If overlaid on a modern map, it would be very near where the Chesapeake Bay Bridge Tunnel crosses the shoreline today. It was called the Pleasure House, and there is still a Pleasure House Road in that area. Apparently it was a popular place for Blackbeard's men to stop and, well…visit. Not wanting to get caught with his pants down (literally), the captain left men behind to serve as lookouts.

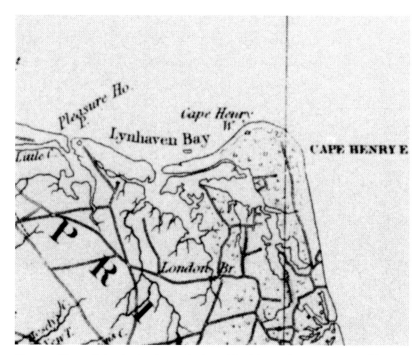

Pleasure House Point is clearly marked on this eighteenth-century map. The actual pleasure house appears on maps from the 1600s. *Courtesy of Virginia Beach Public Library.*

Two or three men would be stationed atop a particularly tall sand dune near Cape Henry, hence the name "pirate's hill." Their job was to watch for approaching ships and send a signal back to Blackbeard indicating if the vessel was approaching from the east or the west. The signal could not be seen from the Pleasure House, so two additional men were placed at another point near the entrance to Lynnhaven Inlet. When a signal was sent from the Cape, one of these men would take the message to the captain. The narrow little road that led to the Pleasure House is now called "Lookout Road."

If a vessel was coming from the east, it was almost always a merchant ship. Blackbeard would take his own ships out into the Chesapeake Bay and wait until the unsuspecting vessel rounded the

Cape. If a ship approached from the west it was either an outbound merchant or a warship, on the lookout for pirates. In either case, Blackbeard would take his ships through a narrow inland waterway that put him out into the ocean somewhere south of Cape Henry. (The exact location of the cut through is not known.) From that location he would be in a position to sail north and intercept a merchant or sail south, ahead of a pursuing warship, and find safety in his North Carolina hideout.

As the story goes, one day shortly before Blackbeard's death, while the pirates were "relaxing" at the Pleasure House, a signal came from the hill indicating that a merchant ship was approaching from the east. When the vessel rounded the Cape, Blackbeard and his men were waiting. The merchant captain loaded his most valuable items into a small boat and, with the help of four other men, quickly rowed to shore. The remaining crew was left to deal with the pirates however they could.

The experienced pirates made quick work of boarding and searching the ship, but it was long enough for the captain to get to the shore. When Blackbeard was told that the merchant had escaped, he was furious. A longboat was launched and, with his six strongest men at the oars, Blackbeard gave chase. The merchantmen, weighed down with their boxes of treasures, were soon caught and killed. As Blackbeard stood over the bodies and admired his valuable trophies he was alerted by the sound of cannon fire.

Looking out at the bay the pirate captain saw two navy vessels bearing down on his ships. He needed to return to his ship immediately. With no time to spare he hastily covered the boxes with sand and branches and returned to his men. They successfully escaped, but were never able to return and reclaim what was rightfully theirs, thanks to Lieutenant Maynard and company.

According to what I was told by my teacher, before the area was made into a state park, prospectors used to come in search of Blackbeard's lost treasure. Some of them brought heavy excavation equipment and spent weeks at a time digging in the dunes but were

always unsuccessful in their quest. The story goes that if anyone ever got close to finding his stash, the headless ghost of Blackbeard would appear, chase them away and move the treasure. The pirate's booty remains unfound to this day.

First Landing State Park is a beautiful nature preserve. If you walk along the trails you will see bald cypress trees growing in the swamp. You will also see Spanish moss hanging from branches and you might spy a red fox or even an eagle. If you venture off the trail, however, you may see something else, especially if you get too close to Blackbeard's lost treasure.

Haunted Highway

One need not be a chamber to be haunted.
One need not be a house.
The brain has corridors surpassing
Material place.
—Emily Dickinson

If a picture is worth a thousand words, then the photograph that accompanies this story should leave very little else to tell: "89 people have DIED on this road since 1977." There have been many, many more, but the records only go back to 1977.

"This road" is Route 60, Shore Drive, formerly, the Ocean Highway. The eighty-nine people are men and women of different ages, races, religions and socioeconomic backgrounds. They have died in every type of vehicular conveyance while traveling in all types of weather. I spent many years assigned to the Ocean Park fire station, whose primary response area includes much of Shore Drive, and I have dealt with several of the traffic fatalities personally. I've pulled bodies from vehicles that were upside down, burned, cut in half and hanging from trees.

WARNING
89 PEOPLE HAVE DIED
ON THIS ROAD SINCE 1977.
ARRIVE ALIVE
DRIVE SAFE AND SOBER

This sign warns drivers of the dangers of Shore Drive in Virginia Beach. An additional five people have died since the sign was last updated in 2005. *Photo by author.*

It's not a road with any one particular type of hazard. It's not narrow, curvy or hilly. The city has tried time after time to eliminate the accident potential areas by installing traffic controls, lowering speed limits, removing trees and adding rumble strips along the road's edge. Nothing seems to help. What is it about this road?

Shore Drive runs along the northern coast of Virginia Beach. It was built in 1928 parallel to the railroad tracks that were constructed around the turn of the century. It was the second east-west highway that connected Virginia Beach to Norfolk. During World War II a portion of the road was diverted around the military facility at Fort Story and through what was then Seashore State Park, a natural area established in the 1930s. To this day, despite the intensive urban growth that is common in all coastal cities, that area of Shore Drive has not changed. This is the area where many of the eighty-nine fatalities have occurred.

Perhaps it's not the road at all, but the area itself—something in the air, so to speak. Traveling Shore Drive from end to end is like time travel. Part of the highway is brightly lit, heavily traveled and closely lined with houses and stores while another portion of the same road is dark, desolate and deserted. The median strip in that area is full of trees whose braches reach up and over to touch the branches of other

trees that line both sides of the road. There are no streetlights and the canopy of leaves prevents even the moonlight from getting through. The little bit of light that spills over the road from your car's headlights only dimly illuminates the swamp and makes the oddly shaped stumps and cypress knees appear to be an army of trolls waiting to devour you if they ever get the chance.

I know from my time in the fire department that radio communications along Shore Drive are very unreliable and frequently nonexistent. Radio signals are simply lost along this stretch and your car radio will play nothing but static. After a few minutes of this you actually begin to worry that perhaps there has been some kind of movie-style disaster and you are the only human left alive on the planet; however, according to Motorola service technicians, this is all caused by a vein of iron ore that runs parallel to the bay front. The iron ore apparently causes radio interference.

Maybe there's something evil nearby that somehow brings about the death of others. In January of 1638, a ship carrying Swiss immigrants sailed into Lynnhaven Inlet to ride out a great storm in safety. Instead, the ship was destroyed by the high winds. When the storm had passed, the bodies of three hundred men, women and children were found along the Lynnhaven River either drowned or frozen to death.

In May of 1700, the county sheriff executed three pirates who had been caught in the area. In the weeks prior to their capture, Captain Lewis Guitarr had commandeered four merchant ships as they sailed fully laden from the Lynnhaven River. In addition to taking several hundred pounds of tobacco as his prize, Guitarr also took a number of hostages onto his own vessel, *La Paix*. On April 29, the HMS *Shoreham* of the Royal Navy was sent to locate *La Paix*. The two vessels met in the Chesapeake Bay between Cape Henry and the Lynnhaven Inlet. The ensuing fight lasted almost eight hours and ended only after *La Paix* had been heavily damaged and run aground.

With thirty-nine of his men already dead, Captain Guitarr vowed that he and the remainder of his crew would not surrender if doing

This is a typical scene along Route 60 in Virginia Beach. The headlights from moving cars can make trees seem to come alive. *Photo by author.*

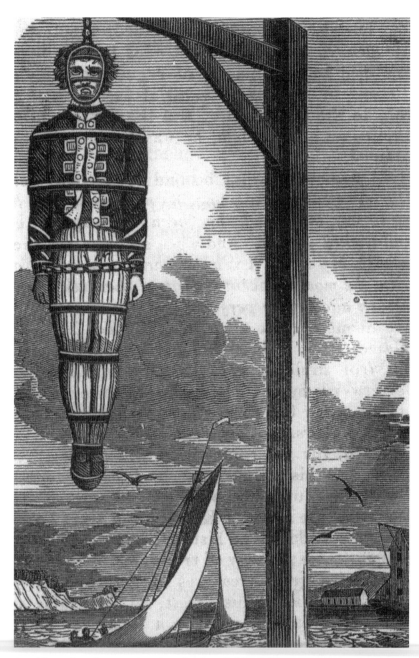

An old woodcut shows a pirate hanging in a "gibbet." The corpses were often left out until they decayed to serve as a warning that piracy would not be tolerated. *Courtesy of the Old Coast Guard Station.*

so meant they would all be executed. Guitarr issued an ultimatum stating that unless the commander of the *Shoreham* agreed to spare the lives of all the pirates on board he would blow the ship up, killing himself, his men and the hostages. It was agreed and the pirates gave themselves up. They were ultimately transported to England for trial and imprisonment.

There were, however, three of Guitarr's men who were not aboard *La Paix* when the negotiations were made. Two had been captured during the earlier fighting; another jumped ship, swam to shore and was apprehended by the local militia. For all intents and purposes these men did not qualify for the pardon, and taking advantage of this little technicality, the Governor of Virginia chose to make an example of them.

After a swift trial the local sheriff was ordered to hang each man near the place where he was apprehended and, as a message to all pirates, to let their corpses hang "until they rott and fall away". One man was strung up near Cape Henry, another at Lynnhaven Inlet and the third somewhere between the two.

It was also near Lynnhaven Inlet where some say they have seen the devil himself. Residents of the area during the early 1700s reported seeing Grace Sherwood, the Witch of Pungo, dancing on the beach with a creature that was half man and half goat. This supposedly happened very close to where Shore Drive crosses over the Lynnhaven Inlet today.

As if all this isn't enough, there's also the burial mound in First Landing State Park that is the final resting place of sixty-four former members of the Chesapeake tribe. The skeletal remains were uncovered in the 1970s and '80s during the excavation and construction of a new portion of Great Neck Road near its intersection with Shore Drive. The positioning of the bones and the unique artifacts found with them revealed to archaeologists that the area had been a burial site for the Chesapeake Indians, a tribe that no longer exists.

The remains were carefully put into boxes and transported to the Virginia Department of Historic Resources where they remained until

INDIAN GRAVE

On April 26, 1997 sixty-four human remains of the Chesapeake Indians were reinterred at this site. The Chesapeake Indians inhabited this area from about 800 B.C. to about 1600 A.D. The landing by the English colonists at Cape Henry on April 26, 1607 while enroute to Jamestown Island was observed by the Chesapeake Indians. The Nansemond Indian Tribe planned and coordinated the reburial ceremony.

This plaque marks the final resting place of sixty-four Chesapeake Indians in First Landing State Park. The graves were uncovered during the construction of Great Neck Road. The Nansemond tribe adopted the remains and arranged for the sacred reburial. *Photo by author.*

they were adopted by a present-day Nansemond tribe and reburied at First Landing State Park.

So just what is it about that certain stretch of road called Shore Drive? It could be any or all of the things I have mentioned or it could be the deadly mix of alcohol and gasoline. Face it, drinking and driving is an evil force in itself and has caused innumerable tragedies.

New Orleans Voodoo

Everything you can imagine is real.
—Pablo Picasso

The magical city of New Orleans offers something for almost everyone: history, music, art, incredible food and, of course, ghost stories. We can only hope that the great city will recover from the devastation wrought by the hurricane season of 2005. Fortunately, you can find a little flavor of the Crescent City right here in Virginia Beach at Eddie Sal's Big Easy. Entertainer Eddie Sal and his business partner opened the restaurant when Eddie's family came to stay with him after being evacuated from the path of hurricane Katrina. As a result, the restaurant offers the most authentic Cajun and Creole cuisine outside of Louisiana. It also serves up its own ghost story.

Donald Berger owned and operated a billiard hall in Virginia Beach for several years. A woman named Betty worked for him as a waitress for most of those years. Fran, a former coworker, says Betty was more like a family member than an employee. Talking about her

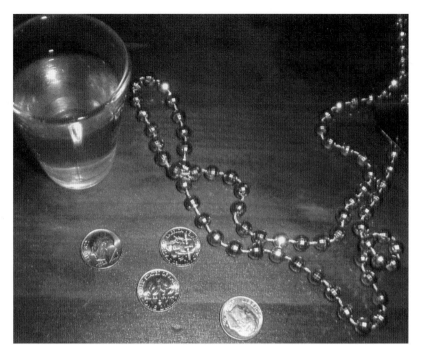

A waitress named Betty haunts Eddie Sal's Big Easy, a New Orleans-style restaurant on Shore Drive in Virginia Beach. Betty has a thing for Wild Turkey and dimes. *Photo by author.*

friend, she recalled two unique habits Betty had: she always took a shot of Wild Turkey at night after work, and she would never pick up a coin off the ground unless it was at least a dime. "She said it was too much trouble to pick up anything less than a dime," recalled Fran. "She'd look down at a penny and say, 'If that was a dime, I'd pick it up.'" Betty died in 2003.

When Don Berger's billiard hall burned down the following year he immediately began looking for a new location to reopen. A popular Asian restaurant on Shore Drive was available, so Don moved in and ultimately partnered with Eddie Sal. While the renovation was underway the two men deliberated on what to name the restaurant's smaller, less formal dining room. In keeping with the New Orleans theme, they agreed to call it the Voodoo Lounge. Don and Fran both

remember that soon after the name was chosen, things changed. Don confessed to me, "Once we decided on that name weird things began happening here."

Don went on to say that each morning they would notice that the bottle of Wild Turkey that was kept at the bar would be moved from the night before. "Once it was over there on the mantel," he said, pointing across the room.

"Sometimes when we come in we find dimes on the floor," added Fran. "Never anything but dimes."

Some of the wait staff at the restaurant say that they have on occasion seen movement out of the corners of their eyes, or even felt an unseen presence, but have never been afraid or upset. Why should they? If Betty were there, it would only be to lend a helping hand. After all, it was the power of true friendship that brought her there, following her former employer to his new restaurant. Or was it the power of voodoo?

The Cape Henry House

At first cock-crow the ghosts must go
Back to their quiet graves below.
—Theodosia Garrison

You would expect the commanding officer of a U.S. Army post to live in the best accommodations available, and that is certainly the case at Virginia Beach's Fort Story, the army's primary Joint Logistics Over-The-Shore (JLOTS) training site. Imagine living in a three-story brick home overlooking the Atlantic Ocean, enjoying your breakfast on the observation deck while frolicking dolphins entertain you in the early morning light. What a dream come true! However, for some of the inhabitants it has been a more like a nightmare.

The building in question was constructed by the U.S. Department of Agriculture in 1918 and served as the Cape Henry weather station until 1969. Described by the builder as "three story and a cellar," it was more than just a weather station; it was also home to the bureau chief and his family. Its oceanfront location and four observation decks provided unobstructed views of the horizon and made it a perfect place for the army and navy to

set up the Harbor Entrance Control Point during World War II. All ships wishing to enter the Chesapeake Bay had to provide the correct password. Once that was received, Harbor Entrance Control would deactivate the several different minefields that protected the channel.

The night of February 16, 1942, was foggy and the minefields were armed. An American tanker, the *E.H. Blum* was approaching the entrance to the bay, and although the identity of the ship was known, it was not given safe entry because it failed to answer radio calls from the Harbor Entrance Control. The 19,000-ton vessel struck a mine that broke the ship in two, the stern section sinking in the shallow water The forward section of the *Blum* remained adrift until the next day, when it was towed into the dock. The aft section was later salvaged and rejoined to the bow.

After the war, the building's primary function was again a weather station. After another twenty years the development of weather radar and satellites made the old building's observation platforms obsolete. When the weather station was closed in 1969, it was renovated, and in the early 1970s it became the quarters for the garrison commandant.

One of the men working at the weather station in 1942 was a retired coast guardsman. One day he received orders that he was being recalled to active duty and would be sent overseas. At age seventy he was unwilling to face the difficult challenge and chose to hang himself instead. His body was found in his upstairs bedroom.

The ghostly image of an old man has reportedly been seen many times at the house. For years it was always seen by children and explained away by their parents as an invisible friend or a bad dream, but recently it was witnessed when the commander's daughter was visiting from college. The young woman was staying in the same upstairs bedroom where the retired man was found dead and was able to describe the man she saw in great detail. Out of curiosity, the girl's father searched through the archives of the weather bureau and found a picture that matched his daughter's description. It was the same man that had killed himself in 1942.

In an article in *Soundings*, a weekly military newspaper, staff writer Devon Hubbard Sorlie talks about another spirit in the old house, now referred to as the Cape Henry House. Apparently, after beds are made, they are later found "rumpled" even though no one had been in the

room. The daughter of the building's first occupant wrote a letter to the base commander in 1984, offering the following explanation:

The family of John Franklyn Newsom lived at the weather station from 1918 until 1933. The family dog, named T.C., spent his entire life at the house. In a letter, Mrs. Zilla Newsom Johnson wrote that she believed it was T.C.'s spirit messing up the bed linens. Messing up the sheets had been a bad habit of the dog's when left alone in the house.

Ms. Sorlie's article also mentions another letter written by a man whose teenage son lived in the house from 1970 to 1972. According to the newspaper article he "often experienced strange things in the northeast bedroom of the house." When I interviewed the current resident he told me that he was aware of the house's reputation and had heard about previous occupants' experiences, but that he had no stories of his own. He was quick to point out, however, that he had only recently taken command of the fort and hadn't lived in the house very long.

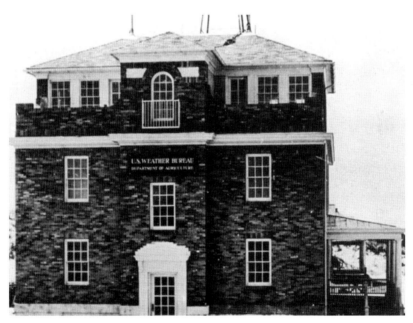

Seen here as a weather station in the 1940s, the Cape Henry House is now home to the commanding officer of Fort Story. The building is haunted by the ghost of a man who hanged himself in one of the bedrooms. *Courtesy of the Old Coast Guard Station.*

The House on Caren Drive

*Imagination is more important than knowledge.
Knowledge is limited—imagination encircles the world.*
—Albert Einstein

On Halloween 2004, a local magazine published a story about local businesses that are reportedly haunted. The article included one of my stories as well as a short bio, which mentioned that I grew up in the Thalia neighborhood. A few days later I received a phone call from a man who had lived for eight years in an adjacent neighborhood, and he wanted to know if I had knew of a haunted house on Caren Drive. I told him no, but that I would like to. We agreed to meet for lunch, and it was there he told me the following story. The man's real name and the exact address are not used to protect the privacy of the home's current occupant.

Steve Miller and his wife Barbara bought a house on Caren Drive in 1980, shortly after they got married. The family they bought from had several children and had lived in the house since

it was built in the 1960s. Except that they seemed a bit anxious to move, the former owners gave no indication that anything about the house was unusual. The building was a two-story brick tract home typical to the time when it was constructed, so there were a few things Steve and Barb wanted to upgrade before they moved in.

A mosaic tile floor had been installed in the foyer to replace the old vinyl one, and the couple was waiting for the new carpet to be delivered for the living room. In the meantime, Steve was painting the home's interior while Barb cleaned out closets, drawers and anything else that needed her help. She found an old ironing board and set it up in the middle of the living room where it became the only piece of furniture in the house and, as such, was used as a table and a trashcan. Steve put a can of paint there so he wouldn't have to bend over to use it, and Barb put things on the ironing board that needed to be discarded. One of those items was a can of the spray-on snow used at Christmastime to decorate windows.

Steve dipped his brush into the paint and was putting a fresh coat on the window frame when he heard a strange sound behind him. It was a metallic, clattering sound and when he turned around to investigate he saw the can of snow rolling across the mosaic tile floor. "There was ten feet of carpeting between where the ironing board was set up and the tile floor," said Steve. "If that can had simply fallen there is no way it could have rolled across ten feet of carpeting." Steve called out to his wife, but she was on the second floor and had been there for at least fifteen minutes.

Steve told me that after living in the house for a while, he became aware of another oddity in the front foyer. Apparently his job required some occasional travel and each time as he said goodbye to his wife in the front hall, the lights would flicker or go out. In addition, whenever he called home from these trips he always had communication problems, usually in the form of heavy static on the phone line. It didn't seem to matter if he was calling from his hotel room or from a pay phone. (Keep in mind that this was before cell phones.)

This prompted Steve to take action against the unseen force, and he asked his local pastor to come and bless the house. He was embarrassed to give the real reason for the request and simply explained that since it was their new home where he would soon be raising his children, he would like to have it blessed. Perhaps being more specific would have made a difference because the unexplained events continued even after the blessing of the house.

On several occasions Steve and Barbara heard noises on the second floor even when the two were home alone. "It sounded like a young boy between sixty and ninety pounds jumping out of bed and running to the window at the end of the hall," explained Steve. There were several neighbors and guests that also heard the sounds. Many visitors, who were not present when the noises occurred, still commented that they felt uncomfortable when they were in the house.

One night when their oldest son was about four years old, Barbara went into his room to tell him good night. He was restless and didn't want to go to sleep. Barbara thought it would help to read the child a story. She selected one of his favorites and prepared to sit down in a chair near the bed when her son said, "Don't sit there, Mommy. There's a man sitting there and he will get mad." Barbara saw no one and asked her son to tell her about the man. Apparently the unseen man was also the reason the boy was extremely afraid of his closet.

On another night, a couple of years after the birth of their second son, Barbara was walking past their bedroom and for some reason was impelled to open the door and look in on them. The two boys were together in the older one's bed and both were sound asleep. Barbara noticed a mist hovering above their heads. It was slightly green in color and constantly undulating. Steve told me it was "some kind of life or spirit force." It was present for about thirty seconds before it disappeared. "It wasn't steam," added Steve, "and it certainly wasn't cold enough to see your breath."

In our interview Steve never once said that he thought the house was haunted, but used the term poltergeist to describe the activity

he had experienced. He told me that in his understanding of the word it seemed very likely that the children who had originally lived in the house had simply left some of their energy behind. Still, he was glad to move out of the house in 1988. Only then did his sister-in-law tell Steve and Barbara of her own experience. Before the couple had moved into the house, the sister-in-law was there alone one afternoon and heard doors slamming all through the building. She left very quickly and never did like going to visit her sister.

The Old Coast Guard Station

Ghosts, we hope, will always be with us
that is, never too far out of the reach of fancy.
On the whole, it would seem they adapt themselves well,
better perhaps than we do,
to changing world conditions—they enlarge their domain,
shift their hold on our nerves,
and, dispossessed of one habitat, set up house in another.
—Elizabeth Bowen

P rior to 1871, surviving a shipwreck along the Atlantic coast depended on where you were. Most of the coast was desolate, unpopulated and offered little hope for rescue. Around major ports, however, increased ship traffic and vigilant coastal residents improved the likelihood of being saved. The Massachusetts Humane Society was a volunteer service established in 1787 to rescue and assist shipwreck victims along the state's coast. In the 1840s and '50s Congress haphazardly approved funding for a few unmanned "boathouses" that were constructed along the New York and New

The keeper of the Cape Henry Life Saving Station posed with his family for this dramatic photograph, dated 1911. *Courtesy of the Old Coast Guard Station.*

Jersey shorelines and a few along the Delmarva Peninsula as far south as Cape Charles. After the American Civil War, several political appointees began working at the boathouses, but for the most part they were unskilled and did little more than just collect their paychecks. However, after the winter of 1871 when unusually violent storms caused a major loss of life and property in that region, public outcry brought about much needed changes.

That year the United States Life Saving Service (U.S.L.S.S.) was formed under the leadership of Mr. Summer Kimball and the existing boathouses became station houses. The appointees were replaced with trained and dedicated lifesavers or surfmen. A new district, District 6, extended from Cape Henry to Nags Head. Congress appropriated $100,000 to build and equip additional stations in the new district as well as along the coast of Maine. In 1874, three new lifesaving stations were constructed in Virginia: Cape Henry, Dam Neck Mills and False Cape. Four years later Station No. 2 was erected in the Seatack area of the city. The rest of the stations in District 6 were also completed that same year. The Seatack station (later called the Virginia Beach station after the town was formed in 1908) is believed to be the first permanent structure in the city. In 1903, the original structure was moved across Atlantic Avenue where it became the city's first post office; a new Seatack station was constructed at the original site. In 1915 the U.S.L.S.S. became the United States Coast Guard and continued to use the new station until it was decommissioned in 1969. In 1981 the building was saved from the wrecking ball and declared a historic landmark. Located on Atlantic Avenue at the end of Twenty-fourth Street, the building is now the Old Coast Guard Station Museum and is dwarfed by the surrounding hotels. It is said that big things come in small packages, and considering the amount of history associated with that little building, it must be true.

In the thirty-seven years as U.S.L.S.S. Station No. 2, the men of the Seatack station responded to approximately 189 shipwrecks, which averaged to one incident every six weeks. (Keep in mind they only worked six months a year—from October 1 to April 1.) In the early years, before Virginia Beach had a doctor, all the shipwreck

victims had to be taken to nearby Norfolk whether they were alive or dead. The fifteen-mile trip was made by wagon and could be a difficult passage, especially at night or during bad weather. As a result, there were often days when it was not practical to attempt the journey and this caused a problem. Shipwrecks most often occurred during bad weather when it is not possible to get to the needed facilities. This meant that on occasion there were dead bodies that had to be stored briefly until they could be taken for burial. Placing them in temporary graves was not an option because feral hogs could easily dig them up and feast on them. Obviously, the surfmen would not allow such an indignity and other arrangements were made, but exactly what those circumstances were is not certain. There is a very popular rumor that the bodies were kept in the attic of the station. That might explain some of the weird things that have reportedly happened there.

When the station was being renovated in 1981 the workmen had to deal with all sorts of minor annoyances. At the end of the day the men would leave their tools in a convenient location near where they were working, but the next morning the tools would be found in a completely different spot. Over the course of the project, many hours were spent looking for the lost tools. The pranks continued when, months later, the museum staff began setting up the new exhibits. Frequently and inexplicably things seemed to move during the night. In addition, there seemed to be some problems with the new wiring in the building. It seems that light bulbs were burning out at an unusually high rate and the electricians couldn't find a cause.

I was taught in science class that energy cannot be created nor destroyed; it simply passes from one thing to another. In that case, where does the energy in us go when we die? Does it just float around until it can go into something else? Are those little balls of light that appear in some photographs actually little balls of energy? Ghost investigators call them orbs. By such investigators' own admission about 80 percent of orbs are actually dust particles, water droplets, bugs or something else easily explained. What about the other 20 percent? If it is energy then it makes sense that such energy could cause certain types of electrical

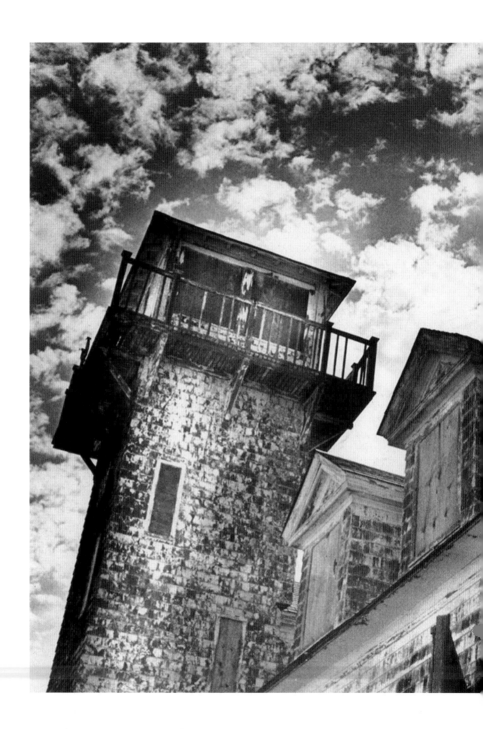

This photo shows the Old Coast Guard Station in 1980. The building had been vacant since 1969 and was in the process of being restored. *Courtesy of the Old Coast Guard Station.*

anomalies in a building. (Although that's not to say that all electrical problems are due to something paranormal.)

Whatever the cause of the power surges at the Old Coast Guard Station, it went away after time. The spirits, however, have not yet left. Many visitors have reported hearing noises from the attic that they describe as sounding like furniture pushed across the floor. They typically shake their head in disbelief when told by the museum curator that no one was up there. There is also what sounds like a woman sobbing in the corner of the lower gallery, referred to by the staff as "the wailing woman." Some people believe it is simply the sound of the wind whistling through the alley behind the building, but others claim she can be heard on windless days as well.

The spirits here also make their presence known to others by reaching out and touching someone. Not literally, but some people say they can feel a presence in the building. Most of us, at some time or another, have had the feeling that someone else was there when we were actually alone. Some people get a tingling feeling and the hairs on the back of their neck stand up. Others actually seem to feel it emotionally: they feel sad, restless, uncomfortable and just plain creepy whenever the spirits are around. Many folks who say they are sensitive to paranormal activity have confirmed to the docents at the museum that there are indeed unseen others in the building.

On occasion, the ghosts at the Old Coast Guard Station actually allow people to see them. The museum's education director, Kate Fisher, had such an experience one Sunday afternoon. The museum had closed for the day and Kate walked from her office to the building's exit. As she went through the lower gallery she observed a man standing silently, apparently looking at one of the exhibits. Kate continued into the gift shop to see if by chance the man was a guest of one of the other staff members, but everyone else had already left. She returned to the gallery to tell the man that the museum was closed and that he would have to leave. As she began to speak, the mysterious man vanished in front of her. Unlike many people who would have quit after such an experience, Ms. Fisher remained at the museum.

The Old Coast Guard Station

A full figure apparition is rare, and Ms. Fisher's disappearing man is the only one that has been seen at the Old Coast Guard Station. There have been many other partial sightings, however. Often, people see a face in a window. It's usually the window at the top of the lookout tower, but the same man's face has been seen in other windows as well.

On a few occasions the police have been called by some well-meaning observer who believed the museum was being burglarized. However, no intruders have ever been found. More often, people arrived at the museum wondering who had been working so late into the previous night, insisting that they had seen someone. When politely told by employees that no one had been in the building, many folks got very indignant. To resolve the issue, a photograph of one of the station's original surfmen was enlarged to life-size, cut out and mounted on foam core. The image was then set up in the tower overlooking the ocean. Now, if anyone reports seeing a face in the window the museum staff just smiles and nods reassuringly.

The photo that was chosen to portray the museum's resident ghost was that of John Woodhouse Sparrow. John Sparrow worked as a surfman at U.S.L.S.S. Station No. 2 for thirty-three years, from 1883 until 1916. He earned the silver lifesaving medal in 1900 for his part in rescuing the passengers and crew of the *Jenny Hall*, a three-mast schooner that ran aground in December of that year. In addition to being a dedicated lifesaver, John was also a loving husband and proud father of several children. John and his wife, Vandalia, lived in a house very close to the station and it was in that house that Mr. Sparrow died on January 25, 1935. According to the obituary in the *Virginia Beach News*, the pallbearers were "men of the Virginia Beach and the Cape Henry station crews." The final tribute to this local hero was "rendered by a firing squad from Coast Guard Base 8."

The ghost of the Old Coast Guard Station could very possibly be that of John Woodhouse Sparrow. One of the reasons spirits remain after their bodies have expired is simply that they are not ready to move on. Certainly Mr. Sparrow's spirit has been offered all the wonderful rewards he earned while here with us, but, being as unselfish as he

was in life, he has probably chosen not to accept them yet and instead remains on duty. Someday, when the building where he spent thirty-three years of his life succumbs to neglect, fire or hurricane, John Woodhouse Sparrow will finally take a long deserved rest.

The same cannot be said for another ghost who seems to haunt the museum. This one is unhappy, confused and even angry. He is believed to be the spirit of a World War II merchant sailor who died when his ship exploded after striking a German underwater mine in June of 1942. His body was recovered by the coast guard and brought to the Virginia Beach station. After several hours it was taken to Norfolk where it was examined at naval headquarters and then buried.

Remember those little balls of energy? Those orbs? Imagine this poor spirit as one of those invisible orbs, unaware of what has happened and possibly believing that he is still alive. Imagine him in the gallery of the museum, going from person to person, asking, "Can you help me? Can you tell me what happened? Can you tell me why I can't get out of here?" That might be the reason why some people have experienced the uncomfortable feelings mentioned earlier. Unlike Mr. Sparrow, this spirit will not rest when the building is no longer standing. It is doomed to remain here until all the questions are answered.

Fire Station 12

Sudden he was called to go
And bid adieu to all below
Sudden the vital spirit fled
And he was numbered with the dead.
— Anonymous tombstone

During World War II, the Civil Defense Department provided money, tools and equipment to areas in Virginia Beach to assist with establishing volunteer fire companies. Station 12, built in the African American community of Seatack, was the only all black fire company in the country at the time. The men of Station 12 served their community bravely and diligently for about twenty years, but as they started getting older it became more and more difficult to find new recruits. The two-story brick building fell into disrepair and was ultimately taken over by the Virginia Beach Fire Department in the early 1970s.

It wasn't long before the city's building maintenance department completed the necessary repairs and upgrades to the building and the career firefighters moved in. A short time later, unusual things started happening at the fire station. It's not at all uncommon to have a few minor electrical problems after a structural renovation, but the two

things that happened repeatedly at Station 12 defied explanation. In the living area on the top floor, the television turned on and off and even changed channels by itself. In the equipment bay on the main floor, all the lights on the fire engine would turn on when no one was in the room. The men of Station 12 began to suspect that their facility might be haunted. Oddly enough, the firefighters were not extremely upset over this. They even came up with a name for their spectral roommate: Irving.

Irving Hoggany was a former member of the Seatack Volunteer Fire Company and was deceased—that much was certain. The exact cause of his death, however, has never been verified. Some say that he died of a heart attack at the fire station; others say he was killed at a bar that used to be nearby. Perhaps he feels like his work at the station is not done or he is seeking revenge on his murderer; either scenario would provide a reason for his spirit to stay behind.

It was about 9:30 p.m. on a July night, and the heat of the day had produced a typical evening thunderstorm. The men on duty at Station 12 were watching television when they heard the front door open and shut. It was locked, but the men were expecting their battalion chief who knew the key code. They heard footfalls on the wooden stairs and expected the chief to emerge from the stairwell at any moment. When he did not, one of the firefighters looked out the window and saw that there was no car out front. He then went to the top of the stairs to see who was there. A cold wind blew in his face. Looking down, he saw wet footprints on the stairs and a puddle of water inside the door, but again there was no one there. He and another man went downstairs and looked around. The door was securely locked, and there were no other footprints or any indication that anyone had recently been in the building. The men laughingly agreed that Irving must have come in from the storm, but secretly at least one of them must have hoped that he had been the victim of a practical joke.

As a fire captain, I was assigned to Station 12 for several years and I know firsthand that some of the men who have worked there will not talk about their experiences with Irving. Either they are extremely frightened remembering their meeting, or they are

The Seatack volunteer Fire Station 12 before it was acquired by the city of Virginia Beach. The ghost of Irving Hoggany is reported to have visited here frequently. *Courtesy of Martin C. Grube.*

worried that no one will believe them. The truth is that none of the firefighters at the city's other fifteen stations were ever critical or judgmental of the men at Station 12. It was just accepted that the Seatack fire station had a ghost.

The firefighters now have a new station just a few miles down the road. My friend Dan was on duty the day they moved, and as he left the old building for the last time, he took a few photos for his scrapbook. When he got his prints back, he noticed that in one of the pictures of the fire station there was a weird mist over one of the windows. Through that mist, it appeared as if a face was peering out from the vacant building. Perhaps it was Irving saying goodbye.

Mayflower Apartments

It is with true love as with ghosts and apparitions.
Every one talks of it and scarcely any one has seen it.
—Duc De La Rochefoucauld

The Mayflower was the tallest apartment building in the state when it opened in 1951. Located on Thirty-fourth Street between Atlantic and Pacific Avenues, the tower has offices, stores and restaurants on the ground floor. A penthouse on the sixteenth floor tops fourteen floors of luxury apartments. It is a coveted residence with few vacancies and many people, once they get settled in, remain there until they take their last breath. Apparently, some stay even longer.

There is a well-known story about the elevators in the Mayflower apartment building. There are four of them and they are originals, installed when the building was being constructed. At any time, any of the four cars will make an unnecessary stop on the fourth floor. You might be riding up to the eighth floor when the elevator will stop at the fourth. When the doors open, you only see the empty hallway.

Apparently the phantom rider must live on the fourth floor because this unusual occurrence doesn't happen on any other floor.

I met author Patrick Evans-Hylton at a local book signing and discovered in the course of our conversation that he has lived in the Mayflower apartments for five years. I asked him about the elevator story. He confirmed it and told me that he's heard other residents blame the "ghost on the fourth floor" for the fact that it sometimes takes a long time for the elevator to arrive. He also told me that he thinks he has lived in a haunted apartment.

"I wouldn't be surprised," he said. "There have been at least ten deaths and one murder since I've lived there. When I moved in it was just a week after they found a resident dead in the same apartment as mine, but two floors below." He added that ever since he moved in he has experienced persistent nightmares in which unknown people appear around him, crying and moaning.

Patrick sketched the floor plan of his apartment and pointed to the walk-in closet near the front door. He is a nonsmoker and lives in a corner apartment with no neighbor on the other side, yet he frequently smells cigarette smoke inside the closet. He said, "It is so strong that I sometimes go out into the hall to see if someone is smoking, but there's never any smoke out there."

He also told me that he has occasionally seen strange things in the apartment. "It's usually out of the corner of my eye," he said, "and it looks like shadows moving around in the entrance hall." He did say that once when he entered the room, he saw a man's figure standing by the front door. For a second he thought it was his roommate, but it was not a familiar form. There was a brief moment of panic when Patrick thought it might be an intruder, but suddenly the figure disappeared. Although relieved that the man wasn't there to rob him, it was still a frightening experience that made Patrick uncomfortable for several days.

There was one other incident: One evening as Patrick was working in his home office he observed the upper half of a man's torso exiting the walk-in closet. It vanished almost immediately and by that time Patrick had gotten so accustomed to such things that he just shrugged it off as another weird incident.

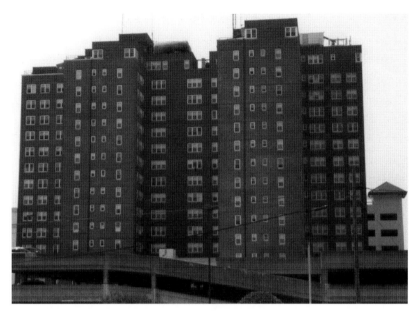

Built in 1953, the Mayflower apartments still dominate the Virginia Beach oceanfront. Elevators stop mysteriously on the fourth floor. *Photo by author.*

One year later, a larger apartment became available and Patrick happily accepted it. "I was actually very glad when we moved," he said, smiling. "I would have taken any place except unit 104."

Apparently, for many years apartment 104 was occupied by an older gentleman. He rarely left the building and depended on his friends and neighbors to get his groceries and medications. It was difficult for him to get up and go to the door so he got into the habit of leaving it slightly ajar. Ultimately he was moved to an assisted living facility although he still held the lease on the apartment. Even though the older man no longer lived there, it was common to walk by and find the door open just a few inches. Patrick told me that one afternoon he was walking with the building manager to inspect another apartment when they found the door of 104 was ajar. The manager shut and locked the door, but when the two men walked past ten minutes later the door was open.

The Ghost of Old Crump

There is a lurking fear that some things are not meant
"to be known,"
That some inquires are too dangerous for human minds to make.
—Carl Sagan

D id you ever have a friend with whom you experienced some
kind of special sensation that you could feel, but maybe not
express in words? Maybe you would say it was "electric" or "magic" or
that the two of you shared some kind of psychic bond. That's the kind
of relationship that Henry Stone and Eugene Burroughs had back in
the early 1900s. In fact, it started in 1898 and continued for forty-one
years. Although Burroughs was a few years older than Stone, it was
truly a "magic" friendship.

Eugene Woodland "Woody" Burroughs lived in a small community
called Sigma near the present community of Sandbridge. Henry
Talley Stone was a few years younger and lived nearby. As a young
man, he had been shot in one eye with a BB and the resulting infection
caused the loss of sight in both eyes, so he became known as "Blind

Stone." As adults, Burroughs became an electrician while Stone worked in a fish market.

One night in 1898 arrangements were made for Henry to sleep over at his friend Woody's house. During that night the boys awakened to find their pillows, bed covers and even the furniture floating around the room. The boys' laughter woke up Mr. Burroughs, who entered the room only to see the boys sitting on their disheveled beds. Woody's father demanded to know what was going on and the two boys told him the honest truth, but he did not believe them. In hopes of scaring the young men into behaving themselves, Mr. Burroughs explained that the two of them had obviously upset the ghost of Old Crump Bonnet who had been killed in the house exactly one hundred years before. The only way they could appease the ghost, Mr. Burroughs claimed, was to be quiet and go to sleep. The plan worked, at least for the remainder of that night.

From then on, whenever Henry and Woody got together Old Crump would come to visit, and objects would mysteriously move around the room. As the years passed the force of Old Crump grew. In his book, *Invisible Forces*, published in 1953, E.W. Burroughs remembers the following:

> *We went to bed early; hardly had we put the light out and gotten into bed before our pillows left the bed and the covering followed. We decided to let the invisible force take everything it wanted and not to get anything back, but the force threw everything back on the bed.*
>
> *Just then a big old-fashioned rocking chair hopped up on the bed. It only felt as heavy as a regular rocking chair when it first landed, but the longer it stayed the heavier it got. We thought it best to put it on the floor, and that is when the wrestle started. It took about 30 minutes to get out from under the chair. We held a little conference and decided to put the chair, pillows and covering out of the room, which we did, the pillows in a big wooden chest in the hall and the chair near the chest. We came back and fastened the door with an old-fashioned night latch. We got back into bed and the pillows from the hall were already there! Again, before we had time to do any investigating, the chair was on the bed.*

The Ghost of Old Crump

As the years passed Burroughs and Stone became well known in their own community and beyond. Edgar Cayce, a world-renowned psychic, and his son, Hugh Lynn Cayce, both observed the antics that occurred when the two men got together. Neither Cayce could disprove what they witnessed: pictures spinning on the wall, window shades going up and down, furniture moving about and disassociated sounds heard from out of nowhere.

In July 1925, Dr. J. Malcolm Byrd, an investigative reporter for *Scientific American* magazine also sat in on the friends' séance and became a believer in the invisible force. Dr. Byrd asked questions and Old Crump responded with a series of knocks and raps on the table. When he asked the spirit to identify itself, the name "Uncle Billy" was clearly heard by everyone in the room. Dr. Byrd was convinced that the invisible force was real and warned Stone and Burroughs that they should never make it mad.

Apparently, Old Crump liked to play with guns. Both Paige and Garland Eaton, whose father was a close friend of Henry Stone, remembered that before Stone and Woody would get together everyone was advised not to bring a gun to the séance. "Somebody would try to sneak a gun in their pocket," said Garland, "and it would always end up floating in the air or something."

Old Crump's achievements were not limited to moving small things. The spirit could move heavy plows, and even people would be lifted off the ground. Burroughs himself sometimes levitated. In Burroughs's book, he tells about an experience that took place at a public séance in downtown Norfolk: A woman sitting in the audience rose from her chair and floated over a man's head. Mr. Burroughs caught the woman by her ankle and tried to pull her down, but she mysteriously floated horizontally just two feet above the floor. The entire time her body was as stiff as wood. When a doctor rushed onto the stage to assist he announced that the woman was dead. After a full ten minutes she awoke and had no memory of what had just happened to her.

Mr. Charles W. Houston, a reporter, attended a séance and wrote about it in the June 27, 1926 edition of the *Virginian Pilot and Norfolk*

Landmark. Houston was a nonbeliever and did his best to reveal the two mystics as frauds. The following are a few excerpts from his article:

Curious things have been done before and have been written about, but Friday night was the first time "Old Crump"—ghost, spook, spirit, ectoplasm or whatever it may be—has ever done his stuff for a representative of the press…

I moved to the other side of the room then and sat very close to Mr. Stone, close enough to observe any movement that might be made by his white clad arms. And I watched closely.

As I was watching something grabbed my chair and the chairs of two or three near me, including the seats of Mr. Burroughs and Mr. Stone, and tossed them helter-skelter, pell-mell into a heap in the center of the room. Sparks flew from the pipe Mr. Stone held in his hand and nothing but a scrambling mass of human legs and arms, intermingled with the legs of the chairs, was visible when flashlights were turned on the center of the uproar immediately after the terrific crash…

Then I got another thrill of tremendous potentiality. I was holding to Mr. Stone's two thumbs with my right hand, to keep tab on his movements or to prevent him from moving. Something like a piece of tissue paper floated down into my lap and rested lightly upon the upturned tips of the fingers of my left hand.

I raised the hand and the weight became greater; then, in less than one-thousandth of the time it takes to tell it, I had tossed the picture to the middle of the floor, as lights were turned on, and, trembling again in every muscle, yelled at the top of my voice, saying things perhaps that should not been voiced anywhere particularly not in the presence of women. Then I dashed for the open air…

Seeing may be believing most of the time, but such is not the case with me. While I would be willing to take an affidavit that all I have written is true, today (Saturday) I feel a bit creepy, but I don't believe it simply because I do not believe in ghosts and suchlike.

There is also a story about a car that would not run if both men were in it. If either Stone or Burroughs got out, however, the car would run perfectly. This resulted in Woody walking a mile and a half to their destination.

No one, not Edgar Cayce, Hugh Lynn Cayce, Dr. J. Malcolm Byrd, Mr. Charles W. Houston— not even Stone or Burroughs—has been able to explain what happened when the two men got together. Was it psychic energy? Poltergeist activity? Hypnotism? Mass hallucination? There were reports of minor events when the next generation of Burroughs and Stone boys got together, but Stone's only son, Garmond, died at a young age so there wasn't time to hone any supernatural abilities.

Perhaps one of the men had a special relationship with a higher power. Paige Eaton shared this story that was told to him by his father, who used to go fishing with Henry Stone. On one particularly hot and windless day, after spending several hours on the water, Stone took a quarter out of his pocket and tossed it into the air. "Hey, God," he said, "how about a quarter's worth of wind?" Before the coin fell into the water a strong wind blew up and the waves began to toss the little boat. It was so intense that Mr. Eaton had to row ashore for fear of being capsized. It was a long, strenuous ordeal to row against the wind and the waves, but finally the men were safe on shore. As Henry stepped from the boat he turned his face upward and said, "God, if I knew wind was so cheap I'd have only bought a nickel's worth."

The Cavalier Hotel

An hour among the dead will do no harm.
—Edwin Arlington Robinson

L ike an aging beauty queen, the Cavalier Hotel stands proudly on the top of a hill and demands to be noticed. Even a casual observer will admire her slightly dated appearance, but someone with a real appreciation for the classics will see her charm and elegance. Anyone who will stop and visit will be overwhelmed by her inner beauty and pure sophistication. Once known as "The Grande Dame of the Shore," the Cavalier has quite a collection of stories to tell anyone who will listen.

When she opened in April of 1927 with 8 stories and 208 rooms, the Cavalier Hotel was the largest brick building in the state of Virginia. Although the guest rooms did not have televisions or coffee makers, they were the state of the art for their time. In addition to the normal hot and cold faucets in each bathroom, there were also taps for ice water and saltwater. (Saltwater bathing was believed to have therapeutic benefits.) In the hotel's lobby there was a radio station (WSEA) and a stock brokerage where guests could keep an eye on their investments with the aide of

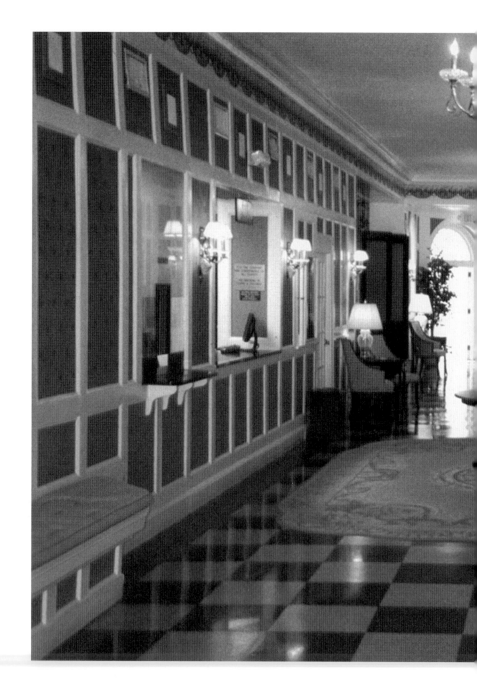

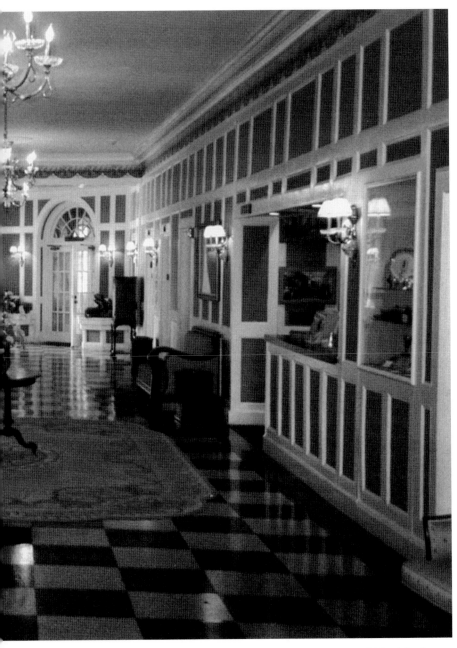

The lobby of the Cavalier Hotel appears today very much like it did back in the 1920s and '30s. With a little imagination you can almost hear the Benny Goodman Orchestra playing in the ballroom. *Photo by author.*

a ticker tape machine. So many limousines and town cars filled the driveway that the hotel had one of its nine dining rooms designated to serve only the chauffeurs.

Through the twenties and thirties the Cavalier Hotel flourished as the east coast resort destination of the rich and famous. Some of the Hollywood celebrities who visited include Judy Garland, Ginger Rogers, Betty Davis, Betty Grable, Jean Harlow, Mary Pickford, Fatty Arbuckle, Will Rogers and Frank Sinatra. F. Scott and Zelda Fitzgerald were also guests there, as were Hank Ketchum, his wife, Alice, and their son, Dennis. Mr. Ketchum was the creator of the *Dennis the Menace* comic strip.

Seven United States presidents have been overnight guests at the Cavalier, and at least three others have been speakers at various functions held there. Until hostilities broke out in Europe, the Cavalier was the place to be and to be seen. During the war, however, things changed considerably. The U.S. Navy took over the hotel and used it for a training facility. By 1950 the Cavalier had reverted back to a civilian hotel, but things were never the same. Americans' travel habits changed and the grand old hotels were being replaced by more modern and convenient motels. In 1973 a new oceanfront Cavalier Hotel opened and popularity fell to the more modern facility. It appeared that a wrecking ball would soon bring an end to "The Grande Dame of the Shore."

To make a long story short, after selling off all the furniture, china and everything else possible, the Cavalier was spared from destruction and is now making a strong comeback. When it is completely refurbished to its original grandeur, it will be a virtual time machine. You might even see some of the visitors from times past.

There are many stories about ghosts at the old Cavalier Hotel. Although the management reamins mute on the issue of hauntings, many of the hotel's current staff, former employees and guests had their own stories to tell. One common tale is of a man who walks the halls at night. The style of his uniform indicates that he is a World War II soldier or sailor, perhaps one of many who perished overseas after receiving his training at the Cavalier. It could be the spirit of a sailor who, while attending radar training school at the Cavalier in 1944, met the woman who would become his wife. The couple had planned to

spend their forty-seventh wedding anniversary at the hotel where they met, but he died just three months before the event in 1991. The man's widow presented the hotel management with the flag that drapped her husband's casket and it was proudly flown from atop the hotel. Could it be that his spirit came back looking for his true love?

The old Cavalier, as it is now known, is not open to overnight guests during the winter months. Only the Hunt Room Grille, located on the basement level, is open year-round. This restaurant is a favorite place for locals to enjoy a delightful evening out, dining in front of a roaring fire. A former employee of the Cavalier Oceanfront Hotel told me stories about working the switchboard during the off-season. She told me she would get phone calls originating from a sixth-floor room in the old building. When she'd answer the calls there was never a word spoken from the caller, but jazz music could be heard through her headset. Initially, she was concerned that that someone was injured or otherwise unable to speak and asked a security officer to investigate. The officer returned to report that the room was not only unoccupied, but also securely locked, as was the entire building. When tourist season began the next spring the operator was scheduled to work at the old building. She instead sought other employment.

That same security officer from the previous story told me of the following experience: One fall evening, as he was walking from the new hotel to the old one, he looked up and noticed that there was a light on in one of the rooms on the sixth floor. He was concerned because, as already mentioned, the hotel was not open at that time of year. All the exterior doors of the hotel were locked and his investigation of the sixth floor found no unlocked doors and no light on. Believing he might have counted incorrectly he also searched the fifth and seventh floors, but the source of the illumination was never discovered. Perplexed, he locked up and headed back to the new hotel. Looking over his shoulder as he walked, he saw there was still a light in one of the rooms on the sixth floor.

There is one other story that involves the hotel's sixth floor. In April 1929, Mr. Adolph Coors checked into the Cavalier Hotel and was shown to his room on that floor. The eighty-four-year-old brewmeister

had retired in 1926, leaving the operation of his brewery to his oldest son, Adolph Jr. As was his custom, Mr. Coors was traveling alone, and there is little known about the purpose of his visit or how he occupied himself while he was at the Cavalier. In his book, *Citizen Coors*, Dan Baum describes Mr. Coors in these words: "He had no hobbies, played no sports, sought no learning beyond his craft...Adolph Coors aged into a dark and joyless reticence, unable to take pleasure in his remarkable achievements."

On June 5, 1929, the lifeless body of Adolph Coors was found on the grounds outside the Cavalier Hotel. The Virginia Beach coroner, Dr. Woodhouse, determined that Mr. Coors had died from a fall. No autopsy was performed and the word suicide is not found on any official papers. Although a note reportedly found in his room stated that a portion of his estate should be used to pay his hotel bill, it is rumored that the windows in his room were found closed and locked. *The New York Times* reported that the famed octogenarian died from a heart attack while dressing.

Whether it is to reveal the true cause of his death or to enjoy himself now that he is free of mortal obligations, Mr. Coors's spirit lingers at the old Cavalier Hotel—so say the numerous people who claim to have seen his ghost there. Apparently, his ethereal image has been witnessed in many areas of the hotel and on one occasion possibly recorded on film. A couple I spoke with told me of attending the wedding of their niece at the Cavalier back in the early 1970s. A professional photographed the wedding party in the hotel's lobby while several relatives took snapshots with their own cameras. The woman said that in some of her developed photos, there was a faint, misty image of what appeared to be a man. She dismissed it as being the fault of her cheap camera and didn't think of it again until she attended another family function a few years later. As the photo albums were being passed around, she noticed similar flaws in other people's pictures. Everyone ultimately agreed the image did look like a man, but no one could identify who it was. When I showed this woman a photo of Adolph Coors, she gasped and said she thought it was the ghostly man in the wedding pictures.

Don't Make Mom Mad

Let us talk of graves, of worms, of epitaphs...
—William Shakespeare

The southern end of Virginia Beach is still extremely rural. Most of the streets and houses have been there at least thirty or forty years. Others have been there much longer. This story was initially told to me by two different people at different times and different places. Neither storyteller knew the other, and I did not ask any leading questions other than, "Do you know any local ghost stories"? Both sources had personal knowledge of the following events, although neither had experienced anything firsthand. The names of those involved have been changed to protect their anonymity.

About thirty years ago a military family was looking for a new home in Virginia Beach. They preferred the quiet, relatively secluded lifestyle offered in the city's south end. They were attracted to one certain house with a prominent ivy covered chimney. As they examined that chimney very closely, they found a letter either etched into the bricks or attached to the brickwork in some fashion. It happened to be the

first letter in the family's last name, so the wife took this as a sign that the house was meant for them. Without searching further they purchased the old house and moved in.

The husband's deployments kept him away for long periods of time, leaving his wife home with only the children as company. At one point, when her husband was home, she mentioned to him that she frequently heard noises in the house and sometimes doors would slam shut without the help of a human hand. After he returned from his next deployment, she told him that at night she would hear screams coming from outside the house or from unoccupied rooms in the house. Later she confessed to her husband that there were "others" in the house and that she was able to talk to them. Needless to say, he didn't know how to respond since he had never experienced anything unusual at the house.

The woman kept her secret as long as possible but eventually began to share her stories with a few close friends. She told them that there were several spirits in and around her house and that they communicated with her. Some of them were friendly; others were not. She admitted that sometimes she was so frightened that she would hide in the house for hours.

Living in fear ultimately took its toll and the woman died a tragic and untimely death in that very house. According to the story, she is now among those spirits with whom she communicated in life. The husband moved out of the house, leaving it the property of the couple's son, Mark, who lived alone in the house.

As time went on, Mark began dating a young woman named Cindy. Cindy said that when she'd visit Mark at the house it was common for him to make joking remarks like, "Don't make Mom mad." She said that once, while in the restroom, she saw an image of a woman who seemed to be peering out of the mirror. Cindy had seen pictures of Mark's mother and recognized the face immediately.

As their relationship developed, Cindy spent more and more time at Mark's house. One evening the couple had a minor "disagreement" that sent Mark upstairs to his bedroom. After a few minutes Cindy went upstairs to apologize. She spoke from outside the closed door;

however, Mark was still angry and suggested that she just go home for the night. Reluctantly, Cindy walked away, but paused at the top of the stairs for just a moment. It was then that a pair of unseen hands pushed her down the stairs. At the bottom she got up, unhurt, and immediately left the building.

Within a week the couple had made up. Cindy convinced herself that she had been upset and had simply fallen down the stairs. On her next visit to see Mark, things were happy and quiet and the two fell asleep in each other's arms. They were awakened by horrible screams coming from outside the house. They cautiously looked out the window to see what could be going on. They saw Cindy's car sitting where she had parked it in the yard. Although there was no one in sight, the car was violently rocking from side to side. Believing it must be vandals or some kind of prank, Mark and Cindy quickly ran out to confront whoever was involved. The car was still rocking as they approached, and the driver's door was open. When they had gotten to within about ten feet of the vehicle everything stopped. Neither saw anyone in or near the car. The car's exterior revealed nothing unusual, but the interior was a total mess. The seats, the headliner and the carpets were all shredded. The word Cindy used to describe it was "eaten."

As I understand things, Mark and Cindy are no longer together. It could be because they just weren't right for each other or perhaps because Mark's mom didn't approve. (In all honesty, that wasn't the kind of thing I was comfortable asking in an interview.) Mark still lives in the house, however, so maybe there will be additional stories to tell when and if he brings future girlfriends home to meet his mom.

Grace Sherwood: The "Witch of Pungo"

The Devil hath power to assume a pleasing shape.
—William Shakespeare

A few miles south of the Virginia Beach's resort area is the small community of Pungo, named for Chief Machiopungo of the Chesapeake Indian tribe. Pungo has always been a successful agricultural area and a place where fish and wildlife are plentiful, but it is best known by the people of Virginia Beach for its beautiful and abundant strawberries. One of Pungo's most famous—or infamous— residents was Grace Sherwood.

The exact year of Grace's birth is uncertain, but was sometime in the mid-1600s. She was the only child of John and Susan White. John was a carpenter and farmer. Grace married James Sherwood in 1680, and as a wedding gift the couple received 50 acres of land from Grace's father. When John White died the following year, he bequeathed the remainder of his 195-acre farm to James and Grace Sherwood.

James and Grace led a quiet life on their farm. Grace bore three children, all boys: John, James and Richard. Very little is known

about their everyday lives, except that Grace had a sense of humor and knew a lot about herbs and their uses. She was known to be the local healer. By all accounts Grace was extremely beautiful and, unlike most women of her time, very outspoken. She preferred to wear men's clothing—which was snugger than women's clothing of the day—when working in the field. The combination of her good looks and the tighter-fitting clothing probably turned a few of the men's heads and made their wives very upset.

In March 1697, James and Grace filed a defamation lawsuit against Richard Capps. The Sherwoods claimed that Capps had publicly accused Grace of being a witch and said that she cast a spell on his cows that prevented them from giving milk. The court dismissed the case when the two parties agreed to a settlement.

Grace and her husband were back in court in September 1698. This time they had filed two suits. The first, again for defamation, was against John and Jane Gisbourne. According to the Sherwoods, Jane Gisbourne had publicly accused Grace of ruining the family's cotton crop by bewitching it and causing it to wither. The second lawsuit, this one filed against Anthony and Elizabeth Barnes, was for an action of slander and sought restitution in the amount of one hundred pounds sterling.

Elizabeth Barnes professed publicly that she awoke one night to see two dark figures standing at the foot of her bed. One of the figures was Grace Sherwood. The second was a tall male, with glowing red eyes and a goat's head. According to Mrs. Barnes, as she got up from her bed the male figure vanished, while Grace suddenly grew fangs and claws, leapt onto Elizabeth's back and rode her around the room. Then Grace turned herself into a black cat and escaped from the room through the keyhole in the door.

Both lawsuits were heard before juries the same day. In the case against the Gisbournes, the jury foreman, Christopher Cock, delivered a verdict in favor of the defendants. The same verdict was reached in the case involving Mrs. Barnes, but in that trial the jury took four days to listen to seven different witnesses brought by the plaintiffs. Finally on September 14, Francis Sayer, the foreman of the jury, announced the verdict. The judge ordered the Sherwoods to pay court costs. The

couple also had to finance the witnesses' time, travel, room and board for the four days of testimony.

In 1701 Grace made another appearance in court, but this time it was to probate her husband's last will and testament. James left the entire estate to Grace. For the next four years things were relatively quiet for Grace and her sons. However, on December 7, 1705, Grace sued yet another neighboring couple, Luke Hill and his wife Uxor, for "trespass of assault and battery."

Grace claimed that Uxor "assaulted, bruised, maimed and barbarously beat" her and she was suing for damages in the amount of fifty pounds sterling. The details of the case are lost, but Grace's case against Uxor was strong enough that a jury found in her favor. However, she was only awarded twenty shillings. Before the month was out, Luke and Uxor Hill had made a formal accusation of witchcraft against Grace.

One of the things Grace was now accused of doing involved traveling to England and back overnight. According to the story, Grace was making lard one evening and discovered she had no rosemary with which to flavor it. At this time there was an English ship anchored in the Lynnhaven Inlet and with all the crew ashore there was no one on board except the cabin boy. Grace rowed out in an eggshell and boarded the ship, bewitching the young boy with supernatural power that allowed him to hoist the anchor and raise the sails by himself. Then Grace conjured up a strong wind that carried the ship to England. After gathering rosemary there, Grace reversed the winds and arrived back before the sun came up the next day. Rosemary has grown abundant in the area ever since.

The fact is, Grace Sherwood certainly may have procured some rosemary that came from England in an eggshell: it was common practice at the time to protect seedlings in eggshells during transport. However, in retellings of the story, the phrase "in an eggshell" was misinterpreted, and the people believed that Grace must be a witch because her entire body could fit inside an eggshell!

Grace ignored the summons to appear in court and so a warrant was issued in which she was ordered to allow herself to be searched

for a "witch's mark." A jury of twelve women was impaneled and on March 7, 1706, Grace's body was searched and the following report filed with the court:

> *Wheras a complaint have been* [made] *to this court by Luke Hill and his wife that one Grace Sherwood of this county was and have been a long time suspected of witchcraft and have been as the last court was ordered to summon a jury of women to this court to search her on the said suspicion, she assenting to the same. And after the jury was impaneled and sworn and sent out to make due inquiry and inspection into all circumstances. After a mature consideration they bring in this verdict—we of the jury have searched Grace Sherwood and have found two things like tits with several other spots: Elizabeth Barnes' foreman.*

If the name of this jury foreman sounds familiar, it's because this was the same Elizabeth Barnes that Grace had sued a few years earlier after Elizabeth proclaimed that Grace had appeared in her room and changed into a cat.

At this point, the local court had done all it was empowered to do, and Grace's trial was sent to an upper court in Williamsburg. The judges there determined that the charges against Mrs. Sherwood were too vague and sent them back to the county court for further examination. As a result of this report, the local court ordered that a second jury of women be called to verify the evidence. Possibly because the women were all afraid of Grace or maybe because they all knew that the trials were an injustice, the sheriff could find no one to volunteer. On the June 7 court date, the judge voiced his displeasure at the women's refusal to serve and ordered them all held in contempt of court. He also told the sheriff to keep Grace in jail, but in order to dispose of the case against her he ordered (with Grace's consent) a trial by ducking.

This trial by water had led to the death of countless women in the previous decade, mostly in the New England area. The procedure called for the accused witch to be bound in some way and thrown into

Grace Sherwood: The "Witch of Pungo"

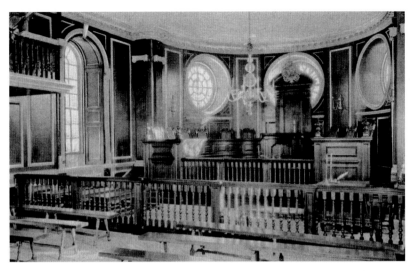

If Grace Sherwood's trial had been held in Williamsburg, it would have been here in the general court building. The high court refused to hear the case and Grace was given the "trial by ducking" in the Lynnhaven River. *Photo from the author's collection.*

water. Since water was regarded as a pure element, it was assumed that it would reject anything evil and welcome the innocent. In other words, if the woman drowned, she was not a witch. If she escaped her bonds and survived, she was declared a witch and killed.

The day appointed for Grace's ordeal was windy and rainy, so, for fear of causing Grace ill health, her trial was delayed until the July 10, 1706. The delay allowed word of the witch trial to spread, not just across the county, but across the state. On the appointed day there was a carnival atmosphere at the site on the Lynnhaven River where Grace was to be ducked. People from as far away as North Carolina had come to see the "witch of Pungo." Although the sun was shining, as Grace was led to her trial she assured the taunting crowd that *they* would get a ducking before the day was over.

Grace was tied with the thumb of her right hand to the big toe of her left foot and the thumb of her left hand to the big toe of her right foot. She was then placed into a small boat where the sheriff and a group of men dropped her overboard in water that was "above a

man's depth." After a brief struggle she came to the surface, free of her bonds. At this point, one of the men in the boat tied a heavy Bible around her neck and pushed her under again. Freeing herself from the Bible, Grace swam around the cove, laughing and singing until she finally swam to shore. She was given over to a group of five "ancient and knowing" women to be searched once again for the "witch's mark." (In 1706 "ancient " denoted that a woman was married and "knowing" inferred that she was aware of the anatomical differences between a man and a woman.) After examining her in private, these women reported that Grace was not like them or any woman they knew. According to them, she had two spots on her private area that were like teats and very dark in color. In reality, these marks were probably moles that protruded from the skin, but it was supposed that any such things were actually nipples for the Devil's sucklings. Since she had survived the dunking and the water had not removed the mark put on her by the Devil, it was decreed that Grace was indeed a witch. She was ordered to be jailed until she could be tried by the Governor's Council. At the end of the day, when Grace had been taken away and the crowd was dispersing, heavy black thunderclouds gathered, and it rained so violently that roads were washed out and large trees were uprooted by the wind. Just as Grace had prophesized, everyone got ducked at the end of the day.

There is no record that a trial was ever held, but Grace remained in the local jail for several years. However, it is said that she never spent a single night behind bars. After dark, the Devil would come get her and they would dance on the shore of the Lynnhaven River until sunrise. The areas of soil where they frolicked have been barren ever since.

After the hysteria of witches and witchcraft passed, Grace was released from her cell. As a sort of compensation for her unjust imprisonment, Governor Spotswood granted her ownership of her husband's land that had been held in probate since his death. On the day she was released she asked the sheriff if he would like to see something he had never seen before. When he answered in the affirmative, Grace ordered a young boy to go to a local tavern and return with two unwashed pewter plates. The boy fetched them but

instinctively dipped the dirty plates into a barrel of water before returning. Grace took the plates, lightly tapped the boy on the head with them and told him to go back for unwashed plates. This time the boy obeyed and when he gave the plates to Grace, she took one in each hand, flapped her arms and flew home, laughing all the way.

Although there are no official records as to how, when or why Grace Sherwood died, her will was probated in 1740. She left everything she had to her son John, with only five shillings apiece to her sons James and Richard.

In spite of her death, rumors and stories continued. One tale says that on the night she died, she had her sons set her barely living body in front of the fireplace. At the moment of her death, a strong wind blew down the chimney, filling the house with smoke and soot. When the room cleared, Grace was gone and there was a cloven hoof print in the ashes, left by the Devil coming to reclaim his own.

A final story tells how it rained for seven days and seven nights after Grace was buried. On the eighth day, Grace's casket floated to the surface. Her sons emptied the water from her grave, lowered her casket and buried it a second time. Another seven days and seven nights of rain followed; on the eighth day, her casket floated up again. This time, a black cat was seen sitting on the casket. Fear that Grace was returning from the grave quickly spread and many neighbors left the area immediately, taking nothing with them. As her sons buried her a third time, the remaining men took up arms and killed every cat they could find. There appears to be some truth to this story, as county records show that in 1743, Pungo Township suffered an infestation of rats and mice, supposedly caused by the lack of cats.

Grace is supposedly buried under a tree that still stands on the property and every full moon feral cats gather, climb into the tree and howl. Many people believe that Grace's spirit rises and joins them. Some residents in the Witchduck neighborhood have reported seeing the image of a woman with long, wet hair walking along the banks of the river at night.

Belinda Nash, the Director of the Ferry Plantation House, has spent many years collecting information about Grace Sherwood. The

This sign marks the entrance to a neighborhood on the Lynnhaven River where Grace Sherwood was tried and convicted of being a witch. Many people believe that Grace lived in this area, but the title of "Witch of Pungo" indicates that she actually resided in a small hamlet in the southern part of Virginia Beach. *Photo by author.*

Ferry House overlooks the exact spot where the dunking took place and was the perfect setting for a very special ceremony. At exactly 10:00 a.m. on July 10, 2006, exactly three hundred years to the hour since Grace's dunking, the mayor read a proclamation by Virginia Governor Timothy M. Kaine to the small crowd in attendance:

"With three hundred years of hindsight, we all certainly can agree that trial by water is an injustice. We can also celebrate the fact that a woman's equality is constitutionally protected today, and women have the freedom to pursue their hopes and dreams…I am pleased to officially restore the good name of Grace Sherwood."

My Mother's Visit

I have good hope that there is something after death.
—Plato

I grew up in the Thalia neighborhood of Virginia Beach. I lived in
the same house throughout my childhood, adolescence and young
adulthood. My parents were very busy with both civic and social
activities, including the Kiwanis Club, the Cape Henry Woman's
Club, a bridge club, the civic league and the PTA. In addition, they
were founding members of the local Baptist church.

After almost completing college I moved out, got married and my
wife and I bought a home in Virginia Beach. I chose to remain in the
city not because of my relationship with my mother and father (which
was strained at best), but because of my employment with the fire
department. As it turned out our new home was only about twenty
minutes away from my parents.

Although I am an only child, my wife was from a family of nine
siblings and over the next fifteen years several of them moved to
Virginia Beach. I became a captain in the fire department, returned
to school and completed my degree. My dad retired from his job and
was able to do a little traveling with my mother before she became
incapacitated with Alzheimer's disease.

Regardless of the way I feel about my dad, I admire the way he dealt with his wife's illness. For many years he stayed home and tended to her needs. When her condition deteriorated until she no longer knew who he was, he arranged to have a hospice nurse stay with her so he could resume his travels. It was after his return from one of these trips that this story takes place.

It was September and I had not yet closed the pool for the winter, so my wife and I had friends over. We were all enjoying the good weather. My father called the house in the early afternoon. I knew that the day before he had returned from a trip overseas, but I hadn't spoken to him since he had returned. In a very businesslike tone he said, "You'd better come over. I think Mom's had a stroke."

I immediately got in my car and headed to his house, but I hadn't gotten far when somehow I knew that my mother had died. I pulled into a parking lot, found a pay phone and dialed 911. The twenty-minute drive seemed like hours. When I got to the house I pulled into the semi-circular driveway and stopped the car behind a fire engine. I entered the house and walked down the hall to my mom's bedroom. She was on her bed with my father standing on one side and two firefighters standing on the other side. I knew the men and it was an uncomfortable situation, but they confirmed that my mother had passed away.

The police came by next. They routinely investigate any death that occurs in a home unless a physician will attest it was not unexpected and was caused by a known medical condition. That was confirmed with the first of many telephone calls. I had to call the funeral home, her brothers and sisters, her friends and others. When all that was done I was finally able to stop, sit down and start thinking about what had happened.

While we sat in the living room waiting for the hearse to arrive, my father started discussing funeral plans with me. The burial plot and the casket had been purchased years before, but there were still small details to work out. On the decision of whether to have the memorial service in the church or the funeral home, he got very vocal. It seems that during my mother's prolonged illness, no

one from the church staff or congregation had ever once visited or offered to assist in any way. Being a founding member of the church, my father felt betrayed. In his anger he chose to exclude the church from every part of his wife's burial. The memorial service would be conducted at the funeral home.

Shortly after mom's body had been removed my wife arrived at the house to console my father. The two of us agreed that he shouldn't remain alone so we took him with us back to our house and invited him to stay in the guest room. I don't know if my father slept well that night, but I know I didn't.

I lay in my bed, unable to shut my eyes. In my mind I was reliving long-forgotten memories and experiencing the whole gambit of emotions that went with them. At some point I finally fell asleep only to be awakened by my mother's voice calling out, "In the church! In the church!"

I sat up in bed. In the darkness I could see my wife next to me, also sitting up. It wasn't a dream. I could still hear those words, "In the church! In the church!" My wife was saying them.

I reached over to awaken her and when I touched her arm it was like closing my hand around a glass of ice water. She was wet with cold sweat. I called out to her but she didn't answer. She just kept saying the same thing, "In the church! In the church!"

Since my wife was diabetic it occurred to me that she might be having an insulin reaction. I got up, went to the kitchen, got the instruments needed to measure her blood sugar and grabbed a soda for her out of the fridge. When I returned to the bedroom she was still sitting up but now she was calling out for my father. She was not calling him by name, but she was calling him by a nickname that only my mother used. "Where's *****? Where is he? Where's *****?" It was not a name my wife knew, but she called it out over and over.

It took less than a minute to test her blood sugar. It was in the normal range. She was not having an insulin reaction. After a few more minutes she stopped calling and lay back down. The next morning she had no memory at all of what had happened during the night; I will never forget.

This is a Victorian "death card" made to memorialize the loss of a family member. In this case, it was a beloved mother. *Photo from the author's collection.*

My Mother's Visit

I never told my father that his wife had been looking for him that night. The memorial service was held in the funeral home. I've never heard from my mother again, even on the rare occasion when I visit her grave.

The Sixty-fourth
Street Ghost

By the grey woods—by the swamp
Where the toad and the newt encamp—
By the dismal tarns and pools
Where dwell the Ghouls...
—Edgar Allan Poe

There is a site at the southern end of First Landing State Park that is called "the narrows." It is actually a narrow channel less than half a mile long connecting Broad Bay to Linkhorn Bay. One side of the channel is private property and boasts many beautiful and expensive homes. The other side is state property and is virtually undeveloped. There is a small cinder block structure that houses public restrooms and a small food concession, a boat ramp for small vessels and a gravel parking lot. A short stretch of the shoreline has been partially cleared to allow for picnicking and sunbathing, but swimming is prohibited in the area due to the swift current. Access to this area is gained via a narrow road, barely two lanes wide. The road is approximately a mile long and is known as Sixty-fourth Street extended.

This is a scene at the narrows, part of First Landing State Park off Sixth-fourth Street. It's hard to believe that this area is less than a mile away from the busy Virginia Beach resort area. *Photo by author.*

On any given day during the summer you will find people enjoying all the site has to offer: kayaking, fishing, sun worshiping and bird watching. When you're there it seems so isolated that it's easy to forget that you're less than a mile from the city's bustling resort area.

In the 1960s, it was the isolation that made the narrows the perfect lovers' lane and a popular place for young couples to go at night after a movie, dance or high school football game. One very cold Friday night in February 1969, two high school sweethearts left the Valentine's Day dance and drove out to the narrows. The young man drove down Atlantic Avenue in a bit of a hurry and made an S.O.B. turn onto Sixty-fourth Street. (S.O.B. meant "slide over, baby": in the days of bench seats and no seat belts, a driver could make his girlfriend get closer to him by making a high-speed right turn.)

The Sixty-fourth Street Ghost

At the end of the block he applied the brakes and prepared to make a slight turn onto the narrow road that led into the state park, but his car hit a patch of ice and he lost control. The car went into a spin and struck a pine tree. The girl was pinned between the tree and the car and died instantly. The driver was not seriously injured and was able to go to a nearby house and phone for help.

In the aftermath, both families suffered terribly. The boy's family was military, and they were transferred about two years later. The young woman's parents stayed in the area, but the constant reminders of their daughter were too much to handle. The pain led to divorce and eventually both parents moved out of the state.

It was about that time the stories started. People passing the area reported seeing the ethereal image of a young woman standing by the road. I had heard the story many times but never from anyone with personal experience until I met Ed Richardson (his name has been changed), a lieutenant commander in the navy. We met at a Broad Bay Sailing Association (BBSA) open regatta. He had come from Richmond by himself and was at the narrows to launch his boat, a twenty-foot Shark catamaran. I was there to make myself available to anyone who needed a crew and as it so happened, Ed did.

We finished the race next to last, but Ed wanted to celebrate because it was his best finish ever. We had a few beers and Ed told me about something that had happened to him the previous night. He had arrived at the beach about 8:30 p.m. on Friday and drove to the narrows to unhook his trailer. He then drove out to get some dinner and visit with an old friend he had served with in the navy. He returned about 11:45 and was going to spend the night in his car. When he got to the end of the asphalt on Sixty-fourth Street he saw a girl standing at the edge of the woods. "She looked real pale," he said, "like she was hurt or scared or something." He stopped his car and walked toward the girl to see if she needed help, but she backed away into the cover of the trees. "I'd move forward and she'd disappear so I'd stop and all of a sudden she'd show up again over to my right, then to my left. Finally she just disappeared completely."

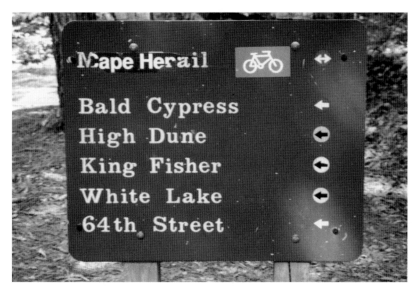

This sign in First Landing State Park marks the bike trail to Sixth-fourth Street where several visitors have seen the ghost of a woman. *Photo by author.*

This is the trail where a bicyclist claims he saw a ghostly figure, believed to be a woman who was killed in an automobile accident. *Photo by author.*

The Sixty-fourth Street Ghost

Even though Ed had downed a couple of beers he seemed very sincere and disturbed by what had happened. When I asked him about the other reported sightings he denied having heard them before. It was still possible that Ed had made the entire thing up, and I still wasn't convinced about the Sixty-fourth Street ghost stories.

However, on an Independence Day in the early 1990s, a bunch of us were just sitting around talking about whatever came up, solving all of the world's problems and the like. When it got to be twilight, the subject of ghosts was mentioned. Over the next hour or so several more people joined in on the conversation and one by one they began sharing personal experiences.

"You're gonna think I'm crazy," one man said, "but this happened to me about two years ago." The man explained that he was an avid bicyclist and that every week he rode the trails through First Landing State Park. Late one afternoon he thought he saw a woman on the trail about twenty yards ahead of him. As he got closer she seemed to step into the woods out of sight. He approached the spot where he had seen her and slowed down so he wouldn't run over her if she suddenly came back onto the path. He didn't see her again, but the air in the area became extremely cold. "It was July or August," he remembered, "but I swear it got cold enough to see my breath." It had happened near the end of Sixty-fourth Street. When I heard that, I chimed in with what I knew about that area. I mentioned the car crash and the story Ed had told me. Unfortunately, no one believed me.

The Ferry Plantation House

Through open doors
The harmless phantoms on their errands glide,
With feet that make no sound upon the floors.
—Henry Wadsworth Longfellow

I t's very possible that the historic Ferry Plantation House is the most haunted structure in Virginia Beach. It was built in 1830 to replace the original manor house that was 185 years old when it burned to the ground in 1827. Although it once was a large plantation, the house is now closely surrounded by many beautiful homes that were constructed in the 1980s. Belinda Nash, who is the director of the house and is responsible for much of the building's restoration, claims there are at least eleven spirits that reside there. Belinda co-authored a book entitled *Ghosts, Witches & Weird Tales of Virginia Beach*, in which she documents many ghostly sightings and eerie events that have occurred at the house. I would like to add some additional stories.

On July 10, 2003, I was participating in the video production of *Ghosts and Legends of Virginia Beach*. We were set up on the second

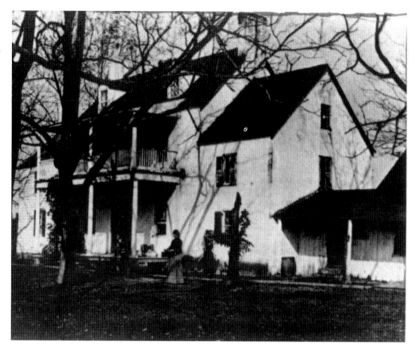

This is how the Ferry Plantation House looked around the turn of the twentieth century. Several of the spirits that now haunt the house were still alive when this photo was taken. *Photo from the author's collection.*

floor of the Ferry Plantation house. A historian portraying Virginia's Lieutenant Governor Alexander Spotswood (acting governor 1710–1722) had just finished a scene where he talked about his role in the fatal attack on the notorious pirate, Blackbeard. As we began filming the next scene, there was a commotion on the building's first floor where a staff meeting was occurring. I went downstairs, politely reminding everyone that we were filming above and that their voices could be heard through our microphones.

"She was just here!" someone said excitedly. Several people then told me that they had seen the ghostly image of a young girl pass silently through the dining room. She appeared to want people to follow her. She had been seen in the house on other occasions but never in the presence of so many people. I returned to the second floor with the

story. Although we completed the filming without further disturbance, we all wished we had been able to film the young girl.

A few months later I was visiting a florist's shop to find something special for my wife's birthday. Like me, the florist was a local, and when we began chatting the subject of the Ferry Plantation House came up. She remembered it as the "witch's house." (Since the house is located close to Witchduck Road, many people mistakenly believe that's where the infamous "Witch of Pungo" lived.) I filled her in on the true story of the witch, Grace Sherwood. This woman then sheepishly told me this story about her childhood experience at the house.

She remembered the Ferry House in the years when it sat abandoned in the middle of a huge tract of open land. There were all kinds of stories about ghosts and witches associated with the house, and she and her friends frequently talked about someday going into it and possibly spending the night. One day a dare was made—an "I'll go if you go" challenge, the kind that no self-respecting teenager can resist. It was decided that they were all going in!

To discourage curious trespassers, a tall chain-link fence surrounded the property; however, it proved ineffective against this group of determined teens. My florist friend told me how they all slowly and carefully scaled the fence and cautiously advanced toward the ominous-looking house. Each one bragged that they wanted to be the first to go through the door, but this woman confessed that she was actually happy to end up second in line.

Moving inch by inch, they stepped onto the porch. When the young man at the head of the line slowly reached out for the doorknob, the boards gave way under his feet and he sank to his waist in a hole. This put the storyteller in an awkward position. She really didn't want to be the sacrificial lamb if there actually was some type of monster inside that door, but she also didn't want to be thought of as a coward by her friends. Her pride won out. She grasped the knob and flung open the big heavy door. She described what happened next:

"It was dark in there, but there was enough light to see. I took about three steps in when the witch came flying straight out of the fireplace. I turned and ran right over my friend who was still trying to get from

the hole in the porch. I didn't stop running till I got home. I don't remember how I got back over that fence."

Being an investigator for the Center for Paranormal Research and Investigation (CPRI), Teddy Skyler was intrigued after reading *Ghosts, Witches & Weird Tales of Virginia Beach*. She contacted Belinda Nash for more details. Ms. Skyler and I had met previously, so when Belinda mentioned my name, Teddy called and asked if I would like to observe a ghost hunt at the Ferry Plantation House. Of course, I accepted.

Except for what I had seen on television I really didn't know what to expect at a ghost hunt, but I must say, I was impressed. After arriving at the appointed time I was introduced to a half dozen men and women who were very professional and who seemed sincere in welcoming me. Teddy's son, Ashton, was wearing a t-shirt that read "Ghost Bait." I was relieved to see him in that shirt because I had worried perhaps that's why I had been invited.

As the crew went about setting up their equipment I talked with them and got a bit of an education. I learned about EMFs (electromagnetic fields), EVPs (electronic voice phenomena), ectoplasm and orbs. After about an hour everything was ready and the investigation began.

I was present in one of the old bedrooms, now called the "green room," when an investigator with the EMF detector reported very high readings. The electromagnetic impulses seemed to come and go in an irregular pattern. To prevent biased or presumptive evaluations, the team had only a vague knowledge of what had previously happened in the house. For example, they did not know that the EMF readings were coming from the area where Stella Barnett had died in 1912 after ingesting poison mushrooms.

I was also following behind Ms. Skyler when she entered what had once been the children's room. The room now serves as the Ferry Plantation gift shop and has a wide variety of unique items for sale, including reproductions of toys from past centuries. Teddy was hoping to communicate with the spirit of Eric, a young boy who is believed to have died from a fall in the mid- to late 1800s. Teddy entered the room, calling Eric's name and saying that she wanted him to come

A washbasin in the "green room" of the Ferry Plantation House. This is the room where Stella Barnett died in 1912 after eating poison mushrooms. *Photo by author.*

out and play. Without explanation, a wooden hoop, one of the old-fashioned toys, rolled away from the wall, made a circle in the middle of the floor before falling over. The professionals were not nearly as amazed as I was.

For the benefit of those who have not yet read *Ghosts, Witches & Weird Tales of Virginia Beach*, I will briefly mention the rogues' gallery of spirits that dwell at the Ferry Plantation House.

Mary is the little girl the staff witnessed during the documentary filming. She is only seen in the dining room of the house, and when she is present, spots will appear and disappear on the walls. Margaret, the spirit of an adult female, is sometimes seen with Mary and sometimes lingering by herself in the dining room.

A woman who visited the house one afternoon told Belinda a story much like the one told by the florist. She too had sneaked into the house when it was still boarded up and was frightened away by a ghostly image. The ghost she saw, however, was that of a young boy standing on the stairs. Belinda says that was Eric.

As mentioned earlier, Eric likes to play tricks and games. When the restoration of the Ferry House was just beginning, a group of students from Old Dominion University were assisting. One young man put a candy bar on the mantle over one of the fireplaces to keep it from melting in his pocket. While the students were busy with their work, the candy bar flew off the mantle and landed on the floor several feet away. The young man picked up his candy bar and put it back on the mantle, only to watch it fall off again and again and again. Eric was at play.

The same group of students also had trouble keeping track of their supplies. Each morning their tools would be in a different place from where they had been left the day before. This was also blamed on Eric.

Another spirit, believed to be that of a servant, is usually seen in the yard. Once, however, he was observed in the kitchen where he crossed the room and walked through a wall. This type of recurring sighting is referred to as a residual haunting. It was later discovered that the building's original stairs had been at that location in the kitchen and that

this servant had a small room above. A psychic visiting the house named the spirit Henry. It is believed that one of Henry's jobs was to escort guests to and from the ferry landing near the house. He would walk ahead and make sure that the trail was clear of branches and other mess.

One of the modern-day neighbors came to the Ferry House one morning, looking for answers. He couldn't understand why the patio furniture in his backyard was frequently moved during the night. Nothing was ever broken or stolen and the motion detectors never turned the lights on, but the furniture would be moved. Belinda looked at a few photographs and was able to determine that the old path from the house to the ferry landing went right through the man's yard. She suggested that perhaps Henry's ghost was moving the furniture to clear the path. The family moved from the house soon afterward.

A tall woman with dark hair was frequently seen standing near a mantle in one of the rooms. A different psychic associated the name Sally with the woman by the mantle. Further research found Sally Rebecca Walke had lived in the house during the years of the American Civil War. Her fiancée was killed in battle and Sally never married. She planted a magnolia tree in the backyard as a token of her love. That magnolia tree is still there.

One of the two small rooms on the third floor of the house was that of the nanny. She is often heard pacing the hallway between her room and the nursery. On the few occasions when she has been seen, she wears a black or dark blue dress. It's believed she might be in mourning for one of the children she had been charged to watch.

Stella, the woman who died after eating poison mushrooms, has not made an appearance but makes her presence known in other ways. At an open house one Halloween night, a costumed interpreter was in Stella's room, the green room. She was addressing a small group of visitors and stepped toward them. She couldn't move because her dress was caught on the bedpost—or so she thought. The others in the room could see that she was not hooked on the bedpost but that the bodice of her dress was definitely being pulled but as if by some unseen hand—perhaps Stella's.

That same night, two young costumed girls were sitting at a small table in the dining room pretending to use an Ouija board. Suddenly,

Sally Rebecca Walke (center) is believed to be the ghost who is often seen near the fireplace at the Ferry Plantation House. Her fiancée was killed in the Civil War, and Sally planted a magnolia tree on the property as a tribute to her love. *Courtesy of the Friends of the Ferry Plantation House.*

in front of several witnesses, the table jumped up several inches and turned about forty-five degrees, scaring one of the girls so badly that she screamed and ran. She not only fled from the room but also left the house in tears and has never been back.

Some of the incidents are nothing more than reports of shadows or cold spots, but Belinda faithfully keeps documented records of all the different occurrences. At the time of this writing, her count is near eighty. She has determined that most of the activity occurs when someone in the house is wearing period attire. Perhaps the spirits feel like they are back with someone from their own time. Why not stop in at the Ferry Plantation House for a visit and see for yourself?

The Lynnhaven House

Do I believe in ghosts? No, but I'm not afraid of them.
—Marquise du Deffand

On Wishart Road near Independence Boulevard, you can find what is believed to be one of the most important old houses still remaining in the United States. It was probably built between 1630 and 1680, although some experts say perhaps as late as 1721. Some of the early owners include the Boushes, the Wisharts and the Olivers.

To tell this story I've drawn information from a newspaper interview that was published in 1973. The Oliver family had recently given their old house to the Association for the Preservation of Virginia Antiquities (APVA). While doing research for a story about the historic house, Helen Crist, a reporter for the Virginia Beach *Sun*, interviewed two former residents and found out something quite unexpected: the house was haunted.

Mrs. Sarah Walke lived in the old house, known as the Wishart House, from 1939 until 1945, and Mrs. Mary Eliza Smith from 1945 until 1950. Both families had worked on the Olivers' farm. Neither

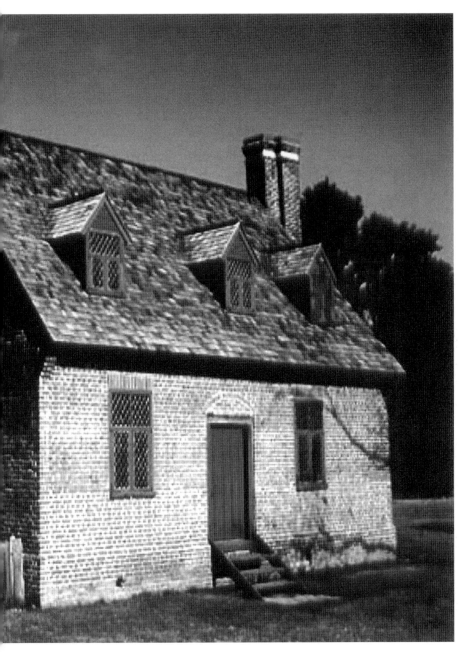

This is an early picture of the Lynnhaven House, before renovation. During the reconstruction, a door was added next to the chimney. *Courtesy of Virginia Beach Public Library.*

was hesitant to discuss the paranormal activity they had experienced in their home.

"We'd be setting downstairs," said Sarah, "and we'd hear sounds like someone walking down the steps, but nobody was. Ooh, it was scary."

Sarah told the reporter this story: "Late in the evening me and my sister came into the dining room and we saw a little girl in a white dress standing in the hallway. She didn't say anything, just stood there." When Helen asked what happened next, Sarah explained the little girl just disappeared.

After a few minutes Sarah told about another ghostly apparition. "One time me and my other sister, Rachael, came into the house and there was a woman just a rocking away." Sarah said that at first they thought it was their mother, but quickly realized it wasn't. "We ran out of the house so fast!" she admitted, but when they cautiously returned a few minutes later, there was no one in the chair.

The newspaper article continues with a story about Jim, an Old Dominion student that was doing restoration of the building's interior. "Definitely, there are ghosts here," he told the interviewer.

According to Crist, Jim first experienced the ghosts when his tools began to move from one place to another without the aid of a human hand. Then doors began to slam closed when he was alone in the house. Being inquisitive by nature Jim decided to investigate.

"I put a cot upstairs, and planned to sleep there one night. But after several hours, it got so cold I had to leave." Although he never saw a spirit he had no doubt there had been one close by him that night.

Ms. Crist wrote an accompanying article about the history of the house, its unique seventeenth-century architecture and the APVA's plans to restore it. The name of the building was changed to the Lynnhaven House when it was determined that the Wishart family was not responsible for its original construction. The house was eventually opened to the public and knowledgeable, costumed interpreters provided information about the building to curious visitors. They did not, however, talk about the ghosts. The APVA strongly discouraged them from discussing the subject for fear that it would taint the credibility of the organization. I talked with a friend

of mine that worked as a volunteer at the house, and when I asked her if the house did have ghosts her reply was, "I wouldn't call them ghosts, exactly."

To help the APVA raise money to maintain the Lynnhaven House each year, a local group of living historians used to set up a Civil War encampment on the property and spend a weekend there. During the day they would assume nineteenth-century personas and portray Confederate soldiers who were recruiting in the area. At night they occasionally witnessed unusual things.

One night, one of the men awakened and saw what appeared to be a person standing in the nearby graveyard. "First he was there; then, he wasn't," said a man named Phil. "I never took my eyes off of him and he just disappeared. I thought about going over to get a better look, but there was no way I was going to do that."

Phil also told me that sometimes, at night, he thought there were people in the building. "It just looked like someone walking past the window," he said. "Once it looked like someone was standing there looking out at us."

The Lynnhaven House has now been taken over by the City of Virginia Beach, and the plans are to resume where the APVA left off. A new education center next to the original building should be completed soon.

Glossary

apparition Literally, anything that appears, especially something startling or unusual. It is more accurately described by the adjective that precedes it: *ghostly* apparition, *floating* apparition, *full figure* apparition.

ectoplasm Believed to be a product of psychic or spiritual energy manifested as a mist, a fog, a solid white mass or a vortex.

electromagnetic field (EMF) Most electronic devices (televisions, lights, etc.) give off electromagnetic impulses, but if detected in an area devoid of such things, EMFs can be an indication of psychic or spiritual energy in the area.

electronic voice phenomena (EVP) Discovered in the mid-1960s by Dr. Konstanti Raudive, a Latvian psychologist and a student of Carl Jung. Raudive found that when audio recordings are made in areas where human spirits are present, voices that were not heard at the time of the recording can be heard during the recording's playback. Many times these spirit voices seem to be interacting with the human voices. They are usually recorded in a range from 0–300 Hz (Human speech is generally within 500–2000 Hz, and has never been recorded below 300 Hz).

ghost The soul or spirit of a deceased person or animal which makes its presence known to the living through mysterious appearances, smells, noises, cold breezes or the movement of objects. "Ghost" is the most popular term used to describe paranormal oddities.

haunting Frequent visitations or occurrences that cause fear, distress or anxiety. These may include apparitions, disembodied voices, smells and moving or disappearing objects.

Ouija board In the mid-1800s there was a great interest in spiritualism. The public's desire to contact the deceased led to the creation and marketing of several different "talking boards." In 1901, William Fuld virtually eliminated all other brands when he patented the "Ouija board" (Ouija is a made-up name and has no meaning). There are two theories on what makes the Ouija board work: The automatism theory says it is ideomotor response—the subconscious mind that causes the planchette (pointer) to spell out answers. Others believe in the spiritual theory that the messages are actually sent by the spirits of the dead.

paranormal Anything that is beyond the range of normal experience or scientific explanation.

poltergeist German for "Noisy Ghost." A general term applied to a variety of physical phenomena that is specific to a particular person or location. Poltergeist activity is thought to be caused by some unusual physical conditions at the affected site or possibly by psychokinesis. One theory suggests that individuals under some form of emotional stress might be more vulnerable to a poltergeist than others. Most poltergeist activity seems to center on a single member of a family, usually an adolescent female.

residual haunting Usually a replaying of an event that is repeated on some type of schedule; it could be daily or annually. It could be as simple as a man walking through a room (as he did every day of his life) or a complex as a great battle scenario. The ghosts that appear in residual hauntings are not spirits and cannot interact with the living. They are merely the images of people whose actions are recorded in time due either to their repetitiveness or to their emotional intensity.

séance A meeting in which someone attempts to communicate with the spirits of the dead.

spirit Similar to a ghost but usually denotes a more benevolent presence. A spirit is the surviving essence or soul of a person with traits, personality and the ability to communicate with the living.

Bibliography

"Adolph Coors." *New York Times*, June 6, 1929, death notices.

"Adolph Coors." *Virginian-Pilot* (Norfolk), June 6, 1929, obituaries.

Ashley, Joan. "Things Go Bump in the Night—and Worse." *Beacon* (Norfolk, VA), September 18, 1977.

Barden, Thomas, ed. *Virginia Folk Legends.* Charlottesville: University Press of Virginia, 1992.

Barrow, Mary Reid. "A psychic twosome pals from childhood." *Beacon* (Norfolk, VA), October 31, 1993.

Barrows-Fisher, Katherine. Personal interview, November 1, 2005.

Batts, Denise Watson. "Spell as 'witch' proclaimed over." *Virginian-Pilot* (Norfolk, VA), June 11, 2006.

Baum, Dan. *Citizen Coors: A Grand Family Saga of Business, Politics, and Beer.* New York: HarperCollins, 2001.

Burroughs, E.W. "The Invisible Forces." Virginia Beach, VA: Self-published, 1953.

"Certificate of Death #16366." Virginia Department of Health. Division of Vital Records, June 5, 1929.

Creecy, John Harvie, ed. *Virginia Antiquary, Volume I: Princess Anne County Loose Papers 1700–1789.* Richmond, VA: Dietz Press, 1954.

Crist, Helen. "Wishart House To Be Restored." *Virginia Beach Sun*, May 4, 1972.

———. "Wishart House Was Home To Them Many Years Ago." *Virginia Beach Sun*, May 4, 1972.

Dapier, Valerie. Personal interview, May 16, 2004.

Dougherty, Kerry. "Ghosts play disappearing act." *Beacon* (Norfolk, VA), November 1, 1990.

Eaton, Garland. Personal interview, June 21, 2006.

Eaton, Paige. Personal interview, June 19, 2006.

Evans-Hylton, Patrick. Personal interview, May 16, 2006.

Fisher, Kate. Personal interview, November 1, 2005.

Fletcher, Ann. Personal interview, January 25, 2004.

Ford, Marlene. "Civic League mulls Ferry Farm ghost." *Beacon* (Norfolk, VA), September 23, 1994.

Gammon, Montague, III. "Trick? Or Treat?" *Hampton Roads Magazine*, September–October 2004.

Giametta, Charles. "Strange But True." *Beacon* (Norfolk, VA), October 30–31, 1984.

Gilbert, Lillie, Belinda Nash and Deni Norred-Williams. *Bayside History Trail: A View From the Water.* Virginia Beach, VA: Eco Images, 2003.

Bibliography

———. *Ghosts, Witches & Weird Tales of Virginia Beach.* Virginia Beach, VA: Eco Images, 2004.

"J.W. Sparrow funeral taking place Friday." *Virginian-Pilot* (Norfolk), January 25, 1935.

"John Woodhouse Sparrow." *Virginian-Pilot,* January 24, 1935, obituaries.

Jordan, James M., IV and Frederick S. Jordan. *Virginia Beach: A Pictorial History.* Virginia Beach, VA: Thomas F. Hale, 1974.

Kyle, Louisa Venable. *The History of Eastern Shore Chapel and Lynnhaven Parish.* Norfolk, VA: Teagle and Little, 1969.

Mansfield, Stephen S. *Princess Anne County and Virginia Beach: A Pictorial History.* Virginia Beach, VA: The Donning Company, 1989.

Nash, Belinda. Personal interview, March 7, 2004.

Pallette, Steve. Personal interview, May 17, 2006.

Pouliot, Richard and Julie Pouliot. *Shipwrecks on the Virginia Coast and the Men of the Life-Saving Service.* Centerville, MD: Tidewater Publishers, 1986.

Rowe, Jane Bloodworth. "Pair of lightning rods attracted 'Old Crump.'" *Beacon* (Norfolk, VA), April 16, 2006.

Sorlie, Devon Hubbard. "Tales from the Crypt…Ghost stories abound at local military installations." *Soundings* (Norfolk, VA), October 27, 2004.

Taylor, L.B., Jr. "The Ghosts of Tidewater and Nearby Environs." Self-published, 1990.

———. "The Ghosts of Virginia, Volume IX." Self-published, 2004.

Tucker, George Holbert. "Grace Sherwood of History and of Legend: Princess Ann's Double Witch." *Virginian-Pilot* (Norfolk), 1949.

———. *Virginia Supernatural Tales: Ghosts, Witches and Eerie Doings.* Norfolk, VA: The Donning Company, 1977.

Turner, Florence Kimberly. *Gateway to the New World: A History of Princess Anne County, Virginia 1607–1824.* Early, SC: Southern Historical Press, 1984.

Tyler, Fielding Lewis. *Fort Story and Cape Henry.* Charleston, SC: Arcadia Publishing, 2005.

"Wealthy Colorado manufacturer, 82, is killed in fall." *Virginian-Pilot* (Norfolk), June 6, 1929.

Whedbee, Charles Harry. *Legends of the Outer Banks and Tar Heel Tidewater.* Winston-Salem, NC: John F. Blair, 1966.

White, Elizabeth Walker. "Legend of 'Witch' Sherwood Haunts Princess Anne County." *Virginian-Pilot* (Norfolk), April 25, 1954.

————. "Meet Grace Sherwood—a Genuine Witch." *Virginian-Pilot* (Norfolk), April 28, 1957.

Williams, Lloyd Haynes. *Pirates of Colonial Virginia.* Richmond, VA: The Dietz Press, 1937.

Yarsinske, Amy Waters. *Virginia Beach: A History of Virginia's Golden Shore.* Charleston, SC: Arcadia Publishing, 2002.

————. *Virginia Beach: Jewel Resort of the Atlantic.* Charleston, SC: Arcadia Publishing, 1998.

About the Author

Alpheus Chewning was born in Richmond, Virginia, in 1954 and moved to Virginia Beach with his parents when he was six weeks old. He attended Friends school and then Princess Anne High School. He went on to earn a B.A. in history and a B.S. in fire administration. He retired from the Virginia Beach Fire Department after twenty-seven years and now owns and operates his own business, The Virginia Beach Ghost Walk. He has had many minor parts in movies and TV shows and has appeared on stage at local theaters. He is the author of two nonfiction books.

Al is a member of the Virginia Storytellers Alliance, the Association for the Preservation of Virginia Antiquities, the Civil War Preservation Trust and serves on the board of advisors at the Old Coast Guard Station Museum.

The author is available to speak about the history (and haunts) of Virginia Beach. If your school, club, civic group or reunion would like to arrange for a program, please contact Al through his website:

Al Chewning. *Photo by Burlo Photo.* http://www.historiesandhaunts.com.